JIM CHURCH'S
ESSENTIAL GUIDE TO
UNDERWATER
VIDEO

JIM CHURCH'S
ESSENTIAL GUIDE TO

UNDERWATER
VIDEO

AQUA QUEST PUBLICATIONS, INC. ■ NEW YORK

Library of Congress Cataloging–in–Publication Data

Church, Jim.
 Jim Church's essential guide to underwater video / Jim Church
 p. cm.
 Includes index.
 ISBN 0-9623389-8-2 : $19.95
 1. Underwater cinematography. 2. Video recordings–
 production and direction. I. Title. II. Essential guide
 to underwater video.
TR893.8.C48 1992
778.5–dc20 92-33722
 CIP

Cover: *Mike Mesgleski videotapes a large manta ray at Little Cayman, B.W.I.*

All photographs are by the author unless credited otherwise. Other photographs by Mike Mesgleski, Wayne Hasson and Geri Murphy.

Printed in Hong Kong
10 9 8 7 6 5 4 3 2 1

Design by Chris Welch.

••• ACKNOWLEDGEMENTS •••

I thank Mike Mesgleski and Ken McNeil for proofreading several drafts of this text, and for making numerous suggestions for improvement.

Mike Mesgleski is a professional underwater photographer, educator and writer. He gave valuable input from a teaching viewpoint, and posed for many of the illustrations. Ken McNeil is an electrical engineer and an avid underwater videographer. He read the first and second drafts, and made important suggestions for improvements.

J.C.

••• FOREWORD •••

Dear Reader,

You don't have to read this book cover-to-cover. Read selectively.

Begin by reading the table of contents. Select only those topics which present what you need to know. Use a highlighter to mark those paragraphs and sentences you wish to remember.

The equipment for underwater videography is constantly changing. Therefore, seek out the general principles presented in this text, and use these as the foundation upon which you can add new facts and ideas. No manufacturer or distributor of underwater video equipment has sponsored, edited or provided financing for this book. It was written independently by me.

I have enjoyed writing this book and sincerely hope you will enjoy using it.

My best wishes,

Jim Church

••• CONTENTS •••

P ART
1
INTRODUCTION

P ART
2
A LOOK AT THE EQUIPMENT

PART
3

SHOOTING TECHNIQUES

PART

4

PLANNING AND EDITING
YOUR VIDEO MOVIE

P A R T

5

APPENDICES

PART

... *1* ...

INTRODUCTION

...*1*...

A New Eye Under the Sea

The huge southern stingrays suddenly appear on the sandy horizon. Gliding in silently and gracefully, they surround us, forming a living wall with their winged bodies.

Within minutes the hungry rays cover us, their mouths greedily searching for food. No, these gentle sea creatures aren't attacking us. They are merely seeking the handfuls of baitfish they expect from visiting divers.

How can you describe such an awesome experience with these creatures of the deep? Verbal accounts can't evoke the same emotion, and photographs taken with a still camera can't depict their fluid motions. Only a camcorder can preserve and convey the emotions, movements and thrills of an undersea encounter with the rays of Stingray City, Grand Cayman, BWI.

You Can Do It

You'll be amazed at how easy it is to shoot your first underwater video. You don't need to master involved theories of photography or understand intricate electronics. Topside, you set a few switches and place the camcorder inside its housing. Underwater, you aim the camera at your subject and press the on/off switch.

The camera automatically adjusts for correct exposure. This eliminates the need to take exposure meter readings or make adjustments. The camcorder's exposure control system responds almost instantly to your subject's brightness. For most shots, shooting is relatively focus free. Everything shot from about one or more feet from a dome port will appear reasonably sharp when viewed on a TV screen.

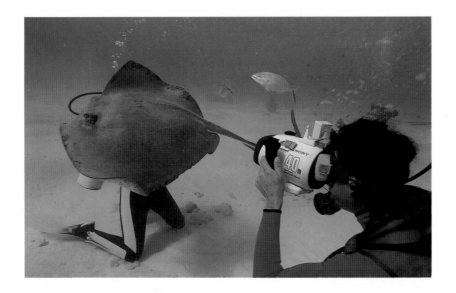

Only a videographer could capture the motion of this encounter with a large stingray.

You'll relive the excitement of the dive when you watch your first videomaking efforts on a TV screen. You'll see your family or friends feeding the fish, swimming over the corals and making discoveries. You'll enjoy the action, excitement and movement. It won't matter for now how well you handled the camera. Your first underwater video experience will be exciting.

● ● ● ─────────────────────────────

You can enjoy underwater videomaking as a snorkeler. The only swimming equipment needed are mask, fins and snorkel. However, practice first in a swimming pool to get the feel of the equipment before heading for the ocean.

If you get serious about underwater videomaking, you should become a certified scuba diver. As a diver, you can videotape as long and as deep as safe scuba limits permit. Is scuba diving dangerous? In my opinion, scuba diving is a safe sport if you are trained and certified by a recognized diving association, only dive with other certified divers and follow safe diving procedures.

──────────────────────────────── ● ● ●

THE SIMPLICITY OF VIDEOTAPE

Buying videotape is simpler than buying film for a still cam-
era. You only need to know the following:

- What format (such as 8mm or VHS-C)?
- What length (such as 30, 60 or 120 minutes)?
- What brand name (stay with well-known brands)?
- What quality (check owner's manual to see if a parti-
 cular quality, such as metal tape, is recommended)?

Unlike photographic film, you don't need different brands
or grades of tape for high and low light conditions, or for
sun or artificial lighting.

CAMCORDERS AND HOUSINGS

For starters, you only need a camcorder and underwater housing.
While virtually any camcorder or video camera can be housed
for underwater videomaking, the most popular choices are 8mm,
Hi8, VHS-C and S-VHS-C camcorders.

Underwater housings are usually cylindrical or molded. Cy-
lindrical housings are basically a section of PVC pipe, with
detachable lids at each end. Cylindrical housings can be adapted
to a large number of camcorders by varying the placement of
camera controls and modifying the interior camcorder mount.

Molded housings are made of plastic or metal. Some plas-
tic housings can be adapted to accommodate several different
camcorders. With transparent plastic housings, you can look
inside for leaks. However, transparent housings may cause flare
or reflections to reach the camcorder lens. Metal housings are
usually cast to fit a specific model camcorder and may be easier
to operate because of their custom design. We will get back
to videotape formats, camcorders and underwater housings
in Chapter 2.

WHAT ABOUT VIDEO LIGHTS

In most clear waters, video lights aren't needed as long as you are out in the open. At distances beyond about five feet, the effect of the light will be minimal. At about three to four feet, the video light provides fill lighting to enhance colors. At closer distances, video light makes close-ups bright and colorful.

If you wish to videotape the darker interiors of Hawaiian undersea lava tubes, or the gloomy insides of the sunken ships in Truk Lagoon, an underwater video light is often needed. For night videomaking, of course, a video light is a must.

You can shoot close-ups with natural light, but a video light gives you the added depth of field for image sharpness. The light also brightens and enhances colors. It's vivid color that makes the red legs of a tiny hermit crab seem to leap out from a TV screen. You don't need high-powered lights for close-ups. A 50-watt video light is all you need, day or night.

A video light brings out the colors and details of fish hiding in dark crevices.

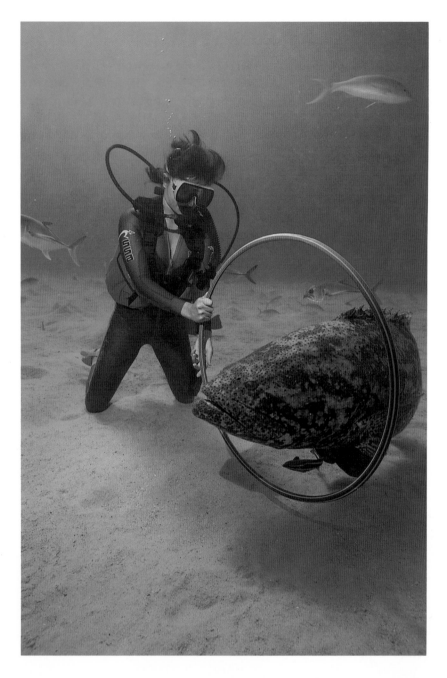

Video captures action, such as this large fish swimming through a hula hoop.

WIDE ANGLE IS IN

Except for close-up shots of tiny subjects, most underwater videomakers use wide-angle lens systems. A wide-angle lens sees a wide area and can include one or more divers in a scene. A wide-angle conversion lens is either screwed into the camcorder lens, or is built into the housing port. Housing manufacturers can usually supply the wide-angle lens needed.

WHAT'S DOWN THERE

Enough of the technicalities, let the thrills begin. At many popular dive sites, hordes of yellowtail snappers will surround you, looking for a handout. Release a small amount of food in the water, and they will perform a feeding frenzy before your lens.

Dive guides often introduce you to their pet eels, groupers and sometimes even an octopus. Most sea creatures won't leap out and grab you. They are shy, and only bite if you shove your fingers into their mouths. The exceptions, of course, are the yellowtail snappers and a few other fish which have the nasty habit of nipping at your unprotected ears. Before your video dive, ask your dive guide for a briefing on the "biters." Because shooting sea creatures with video cameras has become so popular, dive guides often induce their pets to put on a show for you to shoot.

In the Cayman Islands, you can shoot exciting scenes at Stingray City. At the wreck of the *Oro Verde*, you might shoot a 200-pound jewfish named "Sweet Lips." I've taped Sweet Lips as she passed through a hula hoop! Now I ask you, what better way could I share this experience with my non-diving friends?

If you really want excitement, night videomaking is truly a blast. Done properly, and with competent dive guides, night video isn't scary or dangerous. During my underwater photography classes, usually conducted on liveaboard dive boats, some students shoot video every night. Several older students–in

their 60's and early 70's–consider this the best part of the course! Nighttime is when you often find the elusive octopus, the sleeping parrotfish, and delicate coral polyps extended to feed on tiny creatures floating in the water.

You need not travel to the Cayman Islands, Truk Lagoon or any other exotic destination to enjoy underwater videomaking. If your kids are on the swim team or participate in water ballet, you can give them an underwater view of their efforts. It's fun for you, and gives your kids valuable insights which may help them perfect their aquatic techniques. With a few simple props, you can even videotape your own "Cousteau Epic," or other comic video, in the family pool.

THE CREATIVE CHALLENGE

There is a creative challenge. Seeing yourself and your friends on a TV screen is exciting, regardless of the story line. However, don't be fooled by the apparent ease of shooting underwater video. You face the creative challenge of shooting videos which will hold your viewer's attention for more than five minutes!

As you become more experienced, you will discover the importance of good camera handling techniques, an interesting story line, effective editing and appropriate music and narration. To sum up the creative challenge, there is much more to creating a good underwater video story than merely "pointing and shooting."

The following chapters will help you understand how to shoot underwater video, what equipment is needed and how to create exciting video movies.

PART

··· 2 ···

A LOOK AT
THE EQUIPMENT

··· 2 ···

SURVIVING THE
EQUIPMENT JUNGLE

The increasingly vast array of video equipment available to-day forms an "equipment jungle." With some manufacturers updating their camcorders every few months, it's impossible for a book to present current information. Therefore, this chapter will concentrate on the basic buypoints needed to make intelligent choices.

Video cameras need a separate VCR (video cassette recorder) to record on videotape. Camcorders have built-in VCRs. Camcorders are designed to record and playback videotapes in one basic format, such as VHS or 8mm. More about these differences will follow in this chapter.

Full-sized VHS (Video Home System) and Beta video cam-eras and camcorders are fading into history for most sport underwater videomakers. Because video cameras required a separate VCR, both units were placed inside bulky housings. Early VHS and Beta camcorders were also bulky by today's standards because they used full-sized videotape cassettes.

Modern camcorders utilize 8mm and compact versions of VHS videotape cassettes. Thus, modern camcorders are much smaller, and have more features than the older units.

COMPACT VHS (VHS-C)

Compact VHS-C camcorders have been popular for several years. The tape cassette is only about the size of a deck of playing cards and can be placed inside an adapter for playback on a standard VHS VCR. The main advantage of choosing VHS-C

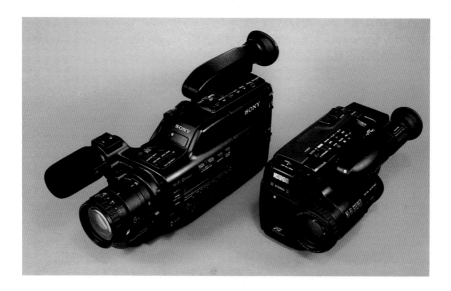

While full-sized 8mm camcorders (left) are popular, the newer "pocket-sized" 8mm camcorders (right) are significantly smaller and lighter.

is that it is compatible with existing VHS VCR's. The main disadvantage is less recording time than the 8mm formats.

SUPER VHS-C (S-VHS-C)

S-VHS-C retains the compact size of regular VHS-C, but this format yields greater picture sharpness. Image quality is 400 lines or more of horizontal resolution as compared to about 220 to 240 lines for regular VHS. The S-VHS-C video cassette has the same basic shell as a regular VHS-C video cassette, but contains a higher quality videotape.

To achieve the full benefit of the increased resolution of S-video (Super VHS or Hi8), you must have a TV/monitor which plays back 400 or more lines of resolution, and which has an S-video input. Your editing equipment (and related accessories) must have S-video inputs and outputs if you edit in

S-video. You can, however, edit from S-video to standard 8mm or VHS formats. The edited tape will have the reduced resolution of the standard format.

STANDARD 8MM

Only about the size of an audio tape cassette, 8mm is the most compact video format available in the United States at this writing. Because of their compact sizes, housed 8mm camcorders are gaining in popularity. As for image quality, I can't see any difference in 8mm and VHS tapes when played on a standard TV set. Both 8mm and VHS yield about 220 to 240 lines of resolution, depending on whose specifications you read.

Compact VHS (left) and 8mm (right) videotape cassettes are smaller than full-sized VHS cassettes (rear).

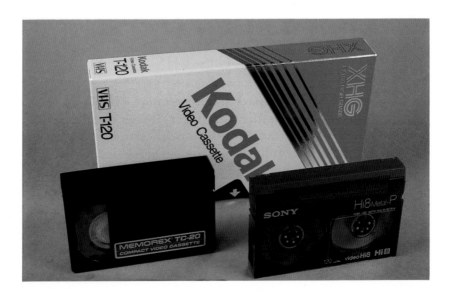

The 8mm format isn't compatible with VHS VCR's, but 8mm VCR's are available. You can, however, run a cord directly from the 8mm camcorder video/audio outputs to the inputs of a TV set or TV/monitor for playback.

HIGH–BAND 8MM (HI8)

Hi8 is to standard 8mm what S–VHS is to regular VHS. The Hi8 format retains the same physical size as 8mm, but Hi8 produces resolution comparable to S–VHS, 400 lines of resolution or more. Special metal videotapes are used for Hi8. Look for a "Hi8" designation on the packaging. If standard 8mm videotape is inserted into a Hi8 camcorder, the camcorder automatically switches to the standard 8mm mode with its lower resolution. Tapes recorded in Hi8, however, can't be played on a standard 8mm VCR.

Maintaining the optimum Hi8 picture requires special equipment. As with S–VHS, the TV/monitor, editing equipment and VCR must have S–video inputs and outputs. (S–video connections are compatible with both S–VHS and Hi8.) Using S–video separates luminance (brightness) and chroma (color) signals, which eliminates the crosstalk (mixing) which occurs in a composite signal. However, even when used with standard 8mm editing equipment, or a TV set without S–video connections, Hi8 tapes produce better images than standard 8mm.

WHICH FORMAT IS BEST

This is a matter of opinion. Currently, I prefer Hi8 because the camcorders are small and videotapes last up to two hours. S–VHS–C is another good choice, especially if you already have a S–VHS VCR. However, at this writing S–VHS–C videotapes can play for only 20 or 30 minutes. Both Hi8 and S–VHS–C camcorders can record and play standard as well as S–video videotapes.

CAMCORDER/HOUSING SYSTEMS

Camcorders and underwater housings are separate items of equipment, usually made by different manufacturers. The camcorder, housing and accessories you choose form your underwater video system. Decide on the videotape format desired, and choose both the housing and camcorder before purchasing either.

● ● ●

Housing manufacturers have already determined which camcorders are the most adaptable to underwater housings, so take advantage of their research and experience. Some of the best housings are offered by small companies whose designers are also underwater videomakers. But be careful, some are poorly designed.

Housing manufacturers can't always house the latest model camcorders. No sooner does the housing manufacturer perfect a mold, than the camcorder manufacturer introduces a new model. Some changes may be more cosmetic than practical. Planned obsolescence seems to be the theme.

Once you have a good camcorder/housing combination, does it really matter if a new model offers fancy features you will rarely, if ever, use?

● ● ●

HOUSING BUYPOINTS

Check each of the following buypoints before investing in a housing. If possible, try the housing in a pool, or at least talk to a satisfied owner before signing your check.

Size and weight. The larger the housing, the more water it displaces, the more buoyant it is and the more lead ballast it needs. Thus, the heavier the system in air. Size and weight can be a royal pain when you're packing the housing for travel or lugging it to a dive boat. Underwater, however, a larger housing is easier to hold steady than a smaller housing. Water pressing against the larger surface area tends to smooth small,

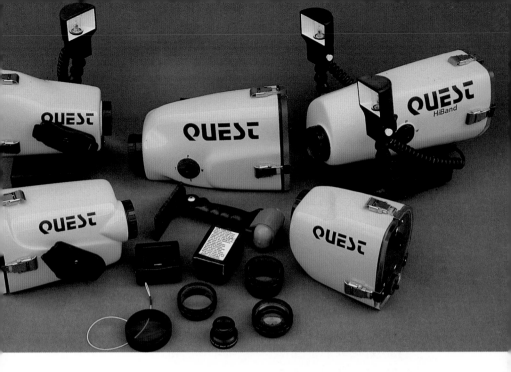

A variety of excellent camcorder housings, video lights and other accessories are available from several manufacturers, such as Quest. Photo: Quest.

Hypertech II housing for Sony TR81 and equivalents. Ports include a flat port with removable filter, and a "wet" dome which can be removed underwater. Photo: Rankin Industries.

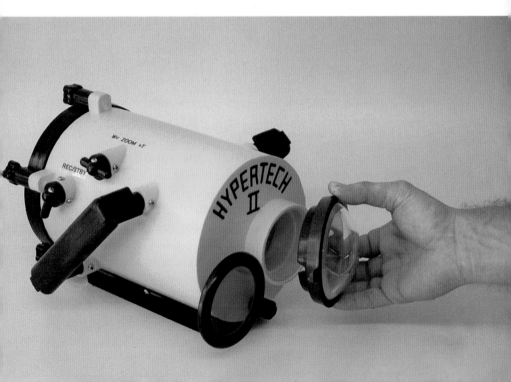

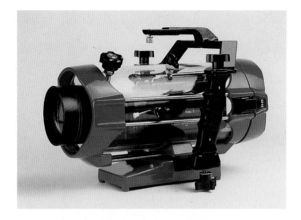

*Ikelite is the largest
United States
manufacturer of
housings for
camcorders. They can
house virtually
anything. Photo:
Ikelite.*

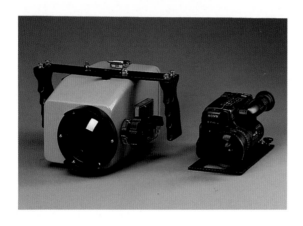

*Gates Underwater
Industries video
housings accommodate
the Sony TR81 and
other video cameras.
Photo: Lee Peterson.*

jerky movements. Only you can determine the happy balance between size and stability.

Buoyancy and balance. With the camcorder inside the housing, underwater buoyancy should be close to neutral. Slightly positive or negative buoyancy is a matter of personal preference. A "floater" will pull you up; a "sinker" will pull you down. An out-of-balance housing tends to tilt upward, downward or to one side, and will fatigue your wrists. If you can't hold the housing comfortably, you won't be able to hold it steady underwater.

Ease of operation. You must be able to operate the basic controls easily! Ideally, you should be able to hold the housing and operate the on/off switch with only the right hand. You often use your left hand to brace yourself and to give hand signals to models.

Electronic controls. I prefer electronic controls that plug into the remote control input of the camcorder. However, electronic controls can fail and can be ruined if the housing floods. Mechanical controls (which utilize pushrods or gears) sometimes slip out of adjustment, and are sometimes awkwardly placed and hard to operate smoothly.

Viewfinder enhancers. Some older housings had a frame-type viewfinder mounted on top. These simple viewfinders are great for following fast action, but are not accurate enough for precision framing. Other housings have a rear port so you can see the camcorder viewfinder, but the viewing screen is usually too difficult to see clearly. For better results, many housings use a built-in viewfinder magnifier to give you an enhanced view of the camcorder's viewfinder. Some manufacturers mount a miniature TV monitor at the rear of the housing. The monitor is a good idea, but it is sometimes hard to view in bright conditions. When evaluating, remember that you will be viewfinding through your dive mask. Bring it along when examining different housed camcorders.

Interchangeable lens ports. Dome ports are best for wide-angle, and flat ports are best for close-ups and macro, regardless of what the salesman tells you! Some flat ports are optically corrected for moderate wide-angle lenses, but dome ports are still best. Choose a housing that accepts interchangeable lens ports if you want versatility.

Wide-angle adapters (conversion lenses). Camcorder lenses usually don't cover a wide enough picture area for underwater use. Therefore, housing manufacturers often build a wide-angle adapter into the port system, or supply a wide-angle accessory lens with the housing. If you have a choice

of wide-angle lenses, go with the higher quality at the higher price. The better lens takes advantage of the 400 plus lines of resolution delivered by the newest camcorders. You usually get what you pay for when you buy a lens.

Exterior microphone. For best audio results, the housing should have an exterior microphone. Otherwise, the built-in camcorder microphone will pick up motor noises inside the housing and won't record exterior sounds clearly.

Video lights and mounts. If the housing manufacturer doesn't also supply video lights, be sure that you can easily attach a light later. Some housings have mounting shoes or tapped holes on the handles for attaching lights.

CAMCORDER BUYPOINTS

Topside, the greater the number of controls, the greater the versatility of the camcorder. Underwater, however, the on/off switch will be the control you use most. So keep in mind, as you read the following buypoints, that some of them will be mainly for topside use.

Standard lens with macro mode. A standard lens (as defined for this text) usually focuses from infinity to about 4 feet. An optional macro mode can be engaged for focusing from a few inches to about 4 feet.

Full-range autofocus macro lens. Some camcorder lenses can be focused from infinity to a few inches, without a special macro mode or supplementary close-up lens. The exact name for this type of lens can vary with different manufacturers.

Zoom lens. Modern camcorders have zoom lenses which allow you to vary the focal length from wide-angle to telephoto. Look for a minimum of 8x zoom capability.

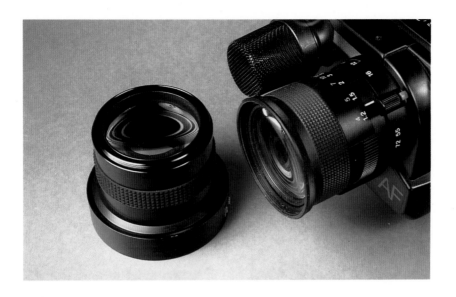

Conversion lenses (left) can be screwed into the accessory threads of the camcorder lenses for wide-angle or telephoto effects.

Automatic Exposure control. This standard feature typically works well underwater. However, some camcorders may consistently under- or over-expose underwater images, so you may need to experiment with the iris override (or gain control) to tailor the exposure to your liking.

Backlight correction. When subjects are backlit, the side of the subject facing the camera will be underexposed. A backlight (or iris) correction switch can increase exposure. No housing (to my knowledge, at this writing) has a backlight control.

Iris override. This is a manual control which allows you to increase or decrease exposure by manually opening or closing the iris aperture.

Gain control. A gain control electronically boosts the video signal for low light conditions. Boosting the signal, however, can degrade the video image.

White balance control. Older video cameras and camcorders needed to be manually white balanced. You aimed the camera at something white while pressing the white balance control to "tell" the camera that the light reflecting from the target was white. With modern camcorders, the only white balancing usually required is setting the camcorder for automatic, daylight or artificial light. A housing control for white balancing is useful for switching from sunlight to video light while shooting underwater.

Variable shutter speeds. Shutter speeds of about 1/60 to 1/125 are used in dim underwater light. Faster speeds are used for extremely bright lighting, such as with upward camera angles toward a bright surface. Topside, fast shutter speeds are great for producing sharper freeze-frame images of moving subjects.

Automatic focus. This is a standard feature. TTL Autofocus generally works well. Sonic systems are defeated by the housing port. Infrared systems are questionable because the infrared beam is absorbed as it passes through water.

Image stabilization. This is a new feature that lessens the effect of shakes and wiggles on the image. Underwater, however, small shakes (such as trembling fingers) are not usually a problem. Water density and resistance slow movements of the housing.

Electronic viewfinder. The built-in electronic viewfinder should be at the rear of the camera (for easy viewing). It should be large enough to see (usually with the aid of a magnifier) when you are wearing a dive mask. The magnifier supplements the electronic viewfinder. It may be built into the housing or may be a separate item.

Fade control. The fade control allows you to fade from a blank screen to a picture, or from a picture to a blank screen. Most housings don't have a control for fading.

Lux rating. The importance of looking for the Lux rating (an indication of how well the camcorder will perform in low light) is declining. Most camcorders now have Lux ratings low enough (about 3 Lux or less) to record images by candle light. However, picture quality declines as the light level falls to the minimum Lux rating of the camcorder.

Titling option. Modern camcorders often allow you to shoot and store titles (letters, dates, etc.) and superimpose these over a scene that you'll shoot later. Most housings don't have a control for this feature.

Time code generator. Some camcorders record a time code on the videotape. This code allows greater editing accuracy with those editing systems that can read the code. Not every editing controller needs or can read time codes on videotape.

Size and weight. As already discussed, size and weight are important considerations, especially if you travel frequently.

Battery power. Choose the battery option with the longest run time. You will probably get about three-fourths of the advertised run time because you don't always use the battery in ideal conditions. If the run time doesn't exceed an hour, it's best to start each dive with a fresh battery.

UNDERWATER VIDEO LIGHT BUYPOINTS

The simplest method of choosing an underwater video light is to see what the housing manufacturers have to offer. If you consider video lights by other manufacturers, be sure that you tell them exactly what housing you have, and if you will use the light for wide-angle, close-up or both applications.

Twin lights are often better than one. Twin lights normally provide better balance, and two 100-watt lights will spread light more evenly over a large picture than a single 200-watt light.

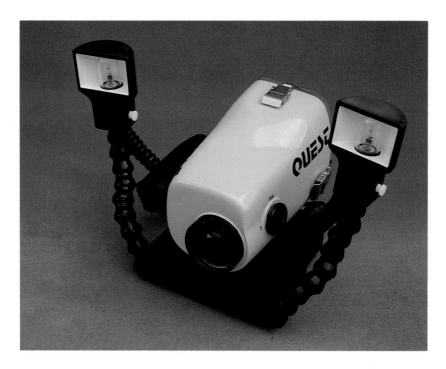

Some nicad battery packs attach to the bottom of the video housing. This allows for smaller lampheads, and the battery replaces lead ballast.

Look beyond the light(s). Look at the adjustable arms for attaching the light(s) to the housing, the wiring connections and the battery location. Check the availability, cost and ease of changing bulbs.

Choosing a video light involves compromise. You must accept some undesirable features to gain those features you want the most. High power outputs and long burn times use battery power quickly. The greater the power and/or burn time, the larger and heavier the battery. You trade off between power output and battery size. Use the following buypoints for your evaluation:

Battery size and location. A large battery stores more electrical energy, but it must be placed somewhere. The three probable locations are inside the camera housing, inside a separate battery pack and inside the video light housing with the lamphead.

If the battery is inside the camera housing, the video light can be smaller. The smaller the light, the lesser the effects of water resistance and surge on the system. If the battery is in a separate battery pack, the pack can be attached to the bottom of the camera housing, to your tank or to your belt. Consider the implications of adding bulk and weight to these locations.

Unless you need a large battery for heavy-duty use, a self-contained video light is a good choice if you travel frequently.

Burn and recharge times. How long (in minutes) will the battery power the light, and how long (in hours) is the recharging time. These are important questions to answer so you will know how many extra chargers and batteries to buy. When traveling outside the United States, check to see if you'll need voltage or plug adapters for your charger.

Power output. The power output is usually expressed in watts. Some video lights may offer different power settings, but changing to a higher- or lower-watt bulb is the common method of changing the power output of most video lights for sport divers.

Beam angle. Some video lights have a high output, but have narrow beam angles. A narrow beam is best for close-up work or with normal-angle lens settings. A narrow beam acts as a spotlight when you use a wide-angle lens, lighting only the central portion of the picture area. I usually use a diffuser to spread the beam for wide-angle fill lighting. A Nikonos SB-102 or 103 strobe diffuser can sometimes be taped over the reflector if the manufacturer doesn't make a wide-angle diffuser. Spreading the beam reduces its intensity, so a higher wattage bulb may be needed.

The "Best" System

While opinions vary, as to what constitutes the "best" camcorder/housing/video light system, my recommendations are as follows:

- An S-video camcorder, either Hi8 or S-VHS-C, with an extra battery.
- A UR/PRO CY filter for bluish water, a UR/PRO GR filter for greenish water, or the color-correcting filters provided by the housing manufacturer.
- The smallest housing that offers good balance, interchangeable lens ports and a viewfinder magnifier. The controls should include conveniently operated switches or levers for: standby/record, focus, zoom and white balance.
- One or more self-contained video lights, for a minimum of 100 watts total power, if you fly frequently. Larger, more powerful lights, with separate battery packs are recommended for professional work.

● ● ● ───

Choosing an underwater video system—camcorder, housing and lighting system—is a matter of determining which features you want the most, and if you can afford to pay for them. You must strike a balance with the performance, bulk and cost of the total system.
─── ● ● ●

··· 3 ···

UNDERSTANDING LENSES AND FOCAL LENGTH

Beginning videographers often skip over this topic because they think it is too technical for them to understand. Actually, the concepts are easy and will help you get the most from your video lenses.

WHAT IS FOCAL LENGTH

The focal length is the distance (shown in millimeters on the lens mount) from the optical center of the video lens to the image sensor. Telephoto lenses have long (high-numbered) focal lengths, while wide-angle lenses have short (low-numbered) focal lengths.

WHAT IS APERTURE

The aperture is the opening that allows light to pass through the lens. The width of the aperture is expressed in "f-stops," such as f/4, f/8 or f/11. The f-number (of the f-stop) is determined by dividing the diameter of the aperture into the focal length. High-numbered f-stops are small openings. Low-numbered f-stops are wide openings.

WHAT IS FOCUS

Think of focus as distance. A lens that has been focused for six feet will produce the sharpest images at six feet. Focus (distance) settings can be made manually or automatically (autofocus). An image that is "in focus" will be sharp because the distance has been set correctly.

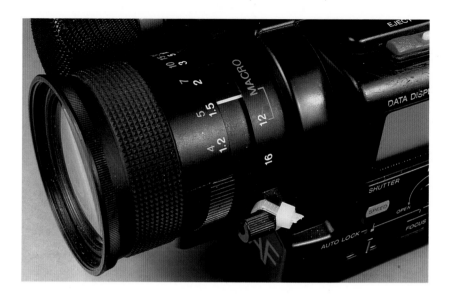

A macro button must be locked in the macro mode for close focusing with standard lenses. If the housing manufacturer doesn't supply a clip, use a tiewrap.

WHAT IS A STANDARD LENS (WITH MACRO MODE)

A standard lens focuses from about 4 feet to infinity. Most standard lenses have a macro mode that focuses from about an inch to 4 feet. To use the macro mode, a button must be depressed on the lens mount. Your camcorder manual may use the term "close-up" when referring to the macro mode.

WHAT IS A FULL-RANGE AUTOFOCUS MACRO LENS

Some lenses can be focused from less than an inch to infinity without having to depress a macro mode button. Thus these lenses are easier to use for close focusing. The names for auto-focus macro lenses vary with different manufacturers.

Zoom Lenses

Most camcorder lenses (standard and full-range macro) are zoom lenses which you can set for different focal lengths, ranging from wide-angle to telephoto. A typical camcorder, for example, may have a 8.5mm to 68mm zoom lens. It can be set for focal lengths ranging from 8.5mm (wide-angle) to 68mm (telephoto).

When compared to the 8.5mm wide-angle setting, the 68mm telephoto setting magnifies subjects eight times, thus it is an 8x zoom lens. For example, suppose a fish videotaped with the 8.5mm wide-angle setting appeared to be two inches long on a TV screen. The same fish would appear to be 16 inches long if videotaped with the 68mm telephoto setting. The 8x magnification makes the fish appear eight times larger.

To determine zoom ratio (magnification) of a zoom lens, divide the telephoto focal length by the wide-angle focal length. The quotient will be the amount of magnification. A 8.5mm to 68mm zoom lens, for example, has an 8x zoom (68/8.5 = 8). (Note: Some writers may refer to 8x as 8:1, pronounced "eight to one.")

Focal Length: Video vs. 35mm

For experienced 35mm still photographers, comparing focal lengths of 35mm camera lenses and camcorder lenses can be confusing. The respective focal lengths are not equivalent.

The following table shows some comparable focal lengths. The first column shows focal lengths for 35mm camera lenses. The second column shows equivalent focal lengths for a camcorder with a 1/2 inch CCD (charged couple device–the electronic "eye" of the camcorder). The third column is for camcorders with a 2/3 inch CCD. The owner's manual will specify if the camcorder has a 1/2 inch or 2/3 inch CCD.

At any given focal length, a camcorder lens has a narrower angle of view than a 35mm camera lens. The camcorder lens "sees" a smaller picture area. For example, a 50mm lens is a

35mm LENS AND CAMCORDER EQUIVALENT FOCAL LENGTHS (Nearest millimeter)		
35mm Lens Focal Length	Camcorder Focal Length	
	1/2 inch CCD	2/3 inch CCD
50mm	9mm	13mm
105mm	19mm	26mm
150mm	28mm	38mm
200mm	37mm	50mm

normal lens for a 35mm camera; its 46–degree diagonal angle of view approximates the view your eye sees. When compared to a 1/2 inch CCD camcorder lens, the 35mm lens' 50mm angle of view approximates that of a 9.2mm lens.

You can transpose approximate focal lengths between 35mm camera lenses and camcorder lenses as follows:

- To convert a 35mm lens focal length to a camcorder lens focal length, divide the 35mm focal focal length by 5.4 for 1/2 inch CCD camcorders and by 4 for 2/3 inch CCD camcorders.
- To convert a camcorder focal length to a 35mm lens focal length, multiply the camcorder lens focal length by 5.4 for 1/2 inch CCD camcorders and by 4 for 2/3 inch CCD camcorders.

FOCAL LENGTH AND ANGLE OF VIEW

The angle of view is a measurement that indicates how much of a scene the lens sees. For camcorders, the angle of view is usually measured horizontally, from one side of the video

picture area to the other. For still cameras, the angle of view is usually measured diagonally from corner to corner. The key idea to remember is that the shorter the focal length (the lower the number in millimeters), the wider the angle of view.

The angle of view is the angle that the camcorder lens "sees." The area seen is called the "picture area."

Published angles of view for camcorder lenses are hard to find, and these angles depend on CCD size as well as focal length. The following table shows some typical comparisons:

HORIZONTAL ANGLES OF VIEW FOR CAMCORDER FOCAL LENGTHS (Nearest degree/millimeter)		
Angle of View	1/2 inch CCD	2/3 inch CCD
50 degrees	8mm	10mm
35 degrees	10mm	14mm
25 degrees	15mm	20mm
15 degrees	25mm	33mm
10 degrees	37mm	50mm
5 degrees	75mm	100mm

If you transpose estimated angles of view for camcorder lenses from 35mm lenses, use the horizontal 35mm angle. Because the aspect ratio (width to height) is 4 to 3 for TV and 3 to 2 for 35mm film, diagonal angles won't match.

FOCAL LENGTH AND VIDEO PERSPECTIVE

Normal lenses. Lenses with "normal" focal lengths (about 50mm for a 35mm camera and about 8mm to 13mm for camcorders) show near and far subjects with "normal" perspective. Their relative sizes are the same as seen by our eye.

Wide-angle lenses. These lenses have shorter focal lengths and wider angles of view than normal lenses. Thus, you can videotape large subjects at closer distances than you can with a normal lens. This is advantageous, because there is less water between camera and subject; therefore, the video images will be sharper and more colorful.

The light and the diver's facial features are enlarged because of wide-angle perspective.

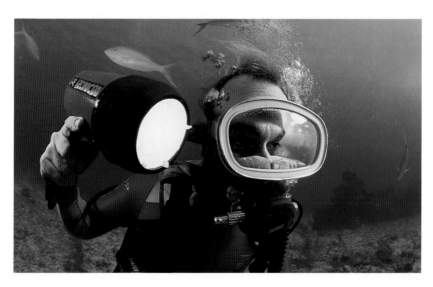

● ● ● ─────────────────────────────

Wide-angle perspective makes near subjects appear larger and closer, and far subjects appear smaller and farther away. This is why a fish swimming close to your underwater video camera appears so large when compared to background divers.
───────────────────────────── ● ● ●

Telephoto lenses. These lenses have longer than normal focal lengths and narrower angles of view. Telephoto perspective compresses size differences between near and far subjects. A good example is the telephoto view taken from behind the pitcher during a televised baseball game. It appears that the pitcher could almost reach out and shake hands with the batter.

● ● ● ─────────────────────────────

Telephoto lenses allow you to shoot close-up views of small marine critters without getting so close that you scare them. Your biggest problem, of course, is camera movement.
───────────────────────────── ● ● ●

Focal Length and Depth of Field

Depth of field is the area in front of the camcorder that will be in sharp focus. If, for example, your camcorder is focused for six feet, depth of field may extend from a near point of four feet and extend to ten feet. While 35mm camera lenses usually have depth of field indicators, I've never seen a depth of field scale on a camcorder lens.

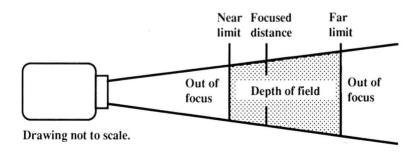
Drawing not to scale.

Depth of field and focal length. The shorter the focal length (the wider the angle of the lens), the greater the depth of field at any given aperture. Conversely, the longer the focal length (the narrower the angle of the lens), the lesser the depth of field.

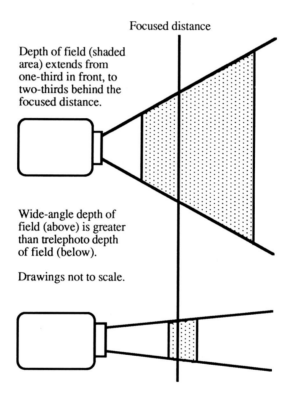

Focused distance

Depth of field (shaded area) extends from one-third in front, to two-thirds behind the focused distance.

Wide-angle depth of field (above) is greater than trelephoto depth of field (below).

Drawings not to scale.

Depth of field and aperture. The smaller the aperture (higher the f-number), the greater the depth of field. The wider the aperture (lower the f-number), the lesser the depth of field. To sum up, maximum depth of field occurs with the smallest aperture and the widest–angle zoom setting. Minimum depth of field occurs with the widest aperture and narrowest–angle zoom setting.

FOCAL LENGTH AND CONVERSION LENSES

A variety of screw-on video conversion lenses are used to change the focal length of the combined camcorder and conversion lens. A conversion lens may be wide-angle or telephoto.

To calculate the change, multiply the focal length of the camcorder lens by the factor of the conversion lens. A conversion lens designated as "0.6x," for example, reduces the effective focal length of a 10mm camcorder lens to 6mm (0.6 x 10mm = 6mm). A wide-angle conversion lens also reduces focused distances to less than those shown on the camcorder lens distance scale. To determine the new minimum focused distance, mount your camcorder on a tripod and aim it at a target (such as a road map) and take measurements.

Wide-angle conversion lenses are often used for underwater videomaking because getting closer to subjects is a major goal. Thus, some housing manufacturers include wide-angle conversion lenses in their housing port systems.

Some video conversion lenses can be reversed for a telephoto effect. A 1.5x telephoto lens, for example, increases the focal length of a 80mm camcorder lens to 120mm (1.5 x 80mm = 120mm). Focused distances will be greater than indicated on the camcorder focus scale. To find the new minimum focused distance, use the road map test described above.

··· 4 ···

UNDERSTANDING FLAT HOUSING PORTS

If you wish to shoot close-up and medium-sized subjects, you will want a flat housing port. While some housings may have a flat port as standard equipment, flat ports are often priced as accessories.

Flat ports are the easiest to use because you are simply shooting through a "window" in the camera housing. However, because of refraction (bending of light rays as they pass though the port), flat ports have a magnifying effect. Subjects appear one–fourth closer than they really are. For example, a fish that is really four feet away will appear to be only three feet away. But not to worry! Your eyes behind a face mask see a subject at the same apparent distance as the camcorder lens. Just look in the viewfinder; what you see is what you get.

Interchangeable lens ports increase your housing's versatility.

Normal Angle with Flat Ports

Although camcorder instructions state that the widest-angle zoom setting is wide-angle, the setting is really normal-angle. The angle of view covers a picture angle close to that which your eye sees when you view a scene.

Autolock Setting

Camcorders have an autolock setting which locks all functions–white balance, focus, shutter speed and exposure–in the automatic mode. The autolock is controlled by a switch lever with some camcorders. With others, closing a sliding cover activates autolock; leaving the cover open turns the autolock off so manual settings can be made.

If you wish all functions to be fully automatic, set the autolock switch for auto. If you wish to use camera controls, electronic or mechanical, to control the functions described in the previous paragraph, turn the autolock off.

Autofocus With Flat Ports

TTL (through-the-lens) autofocus systems work underwater if there is contrast and texture in the central picture area.

Use autofocus when subjects fill the central area of the viewfinder, the subjects have contrast and detail, and when you won't be panning. For best results, trigger the camcorder to standby and aim it at the subject for a few seconds before starting the shot. This gives the autofocus time to react.

Autofocus Problems

Two situations cause problems for autofocus: panning and dim, low-contrast subjects.

A full-range autofocus lens allows you to frame delicate subjects, such as this seahorse.

When panning from one subject to another, autofocus can be confused. For example, suppose your subjects are two divers about five feet away, against a midwater background. You aim the camera at one diver and start the shot. The autofocus senses contrast, and the diver's image is recorded sharply. Then, you slowly pan past the midwater background to the second diver. As he appears in the central viewfinder area, he suddenly shifts from blurry to sharp. What happened? When the autofocus read the midwater background between the divers, it didn't see contrast or detail. It started searching for correct focus, from minimum distance to infinity. Then, after sensing the second diver at the end of your pan, it corrected the focus.

In dim conditions, and with subjects which lack contrast or detail, autofocus often can't lock onto the desired subject area.

MANUAL FOCUS WITH FLAT PORTS

Manual focusing gives you more control. You focus exactly

where you want, and you avoid momentary shifts in focus (as described above). Here is the manual focus procedure:

1. Establish camera-to-subject distance.
2. Aim the camera at that part of the subject which should be the sharpest. When taping divers, for example, aim at their faces.
3. Zoom to telephoto and manually focus for the sharpest image in the viewfinder. (Note: Telephoto may not focus closer than about three feet.)
4. Without changing camera-to-subject distance, zoom back to the desired picture area.
5. Shoot the subject.

Combining Auto and Manual Focus

You can use autofocus to establish correct focus for the desired subject area, and then switch manual focus to hold the desired focus. To do so, modify steps 3 and 4 (above) as follows:

3. Zoom in to telephoto and wait until the autofocus finds the correct focus.
4. Without changing camera-to-subject distance, trigger the manual focus control. Then, zoom back to the desired picture area.

Focusing Flat Port Close-Ups

Full-range autofocus macro focus. Some camcorder lenses will focus as close as the front of the lens port, without having to be set for a special macro mode. With these lenses, use the same focusing procedures as described in the above sections.

Macro mode. Some camcorders have a special macro mode for focusing from the front of the lens port out to about four feet. To place the lens in the macro mode a button must be depressed on the lens. Some housing manufacturers provide a clip for this; others recommend using a plastic tiewrap. The basic macro focusing steps are:

1. Lock the macro mode button in place.
2. Turn the auto lock off.
3. Set for manual focus.
4. Use the zoom control to focus.

Make sure that the macro button is locked in the macro mode position. Otherwise, if you zoom out of the macro mode, you can't get back in without opening the housing and relocking the macro button. Note: The focus setting has little effect on actual focus; focus with the zoom control.

Macro focusing and flat housing ports can produce video images of tiny creatures.

TOPSIDE EXPERIMENTS AND TESTING

You can see the effects of the macro mode, automatic macro focusing and CU lens with the following experiments:

1. Mount the camcorder on a tripod. Aim it at a wall or bulletin board on which you can attach targets.
2. See how close you can focus to the target. See how the zoom affects picture area. See how fast (or slow) the autofocus reacts in dim light.
3. Any measurements you take in air will approximate the apparent distances and sizes you will see underwater.

HOW–TO SUMMARY
USING A FLAT PORT AND SUNLIGHT

1. Turn auto lock off.
2. Set shutter speed for 1/60 or 1/100.
3. Attach color correcting filter.
4. Set lens for widest (lowest number) zoom setting.
5. Set white balance for outdoor.
6. Set for autofocus. (To stay in autofocus, skip steps 8 and 9.)
7. Set to standby.
8. Zoom to telephoto to autofocus.
9. Reset to manual focus to lock focus.
10. Zoom to desired picture area.
11. Shoot the subject.

HOW–TO SUMMARY
USING A FLAT PORT WITH VIDEO LIGHT

1. Turn auto lock off.
2. Set shutter speed for 1/60 or 1/100.
3. For close-ups, remove color correcting filter.

4. Set lens for widest (lowest number) zoom setting.
5. Set white balance to indoor for close-ups.
6. Set white balance for outdoor for distances beyond two feet.
7. Remove filter. Set white balance for automatic for mixed video and sunlight at medium distance.
8. Set for autofocus (To stay in autofocus, skip steps 11 and 12.)
9. Set for standby.
10. Turn video light on.
11. Zoom to telephoto (partial telephoto for close-ups) to set focus.
12. Reset for manual focus to lock focus.
13. Zoom to desired picture area.
14. Shoot the subject.
15. Turn video light off.

If your housing doesn't have a white balance control, or if you are uncertain whether you should use indoor or outdoor, set the white balance for automatic.

LIMITATIONS OF HOW-TO SUMMARIES

You may need to modify the how-to summary lists to fit the controls your housing has and the manufacturer's instructions for your specific equipment. Using auto white balance is explained further in Chapter 11.

··· 5 ···

UNDERSTANDING DOME HOUSING PORTS

*Dome-shaped housing ports, which are often standard equip-
ment for housings, are often a mystery to beginning
underwater videographers. This chapter will tell you what
dome ports are and when you should use them.*

WHAT IS A DOME PORT

A dome port has a half-spherical shape. Dome ports are used
for wide-angle photography with video and still cameras.
Most video housings have a dome port, or a dome port can
be installed by the user.

A dome port acts as a lens; it focuses on a virtual (appar-
ent) close-up image about a foot or less in front of the dome.
(The exact distance varies with the diameter of the dome.) Your
subject, for example, may be a fish six feet away. To a lens
behind a dome port, however, the fish may appear to be only
one foot away. Thus, the camcorder lens must be able to fo-
cus down to a foot or less.

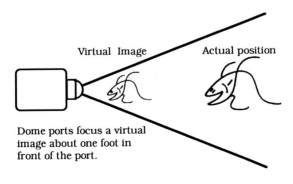

Virtual Image Actual position

Dome ports focus a virtual
image about one foot in
front of the port.

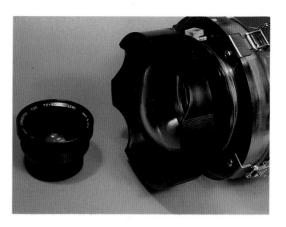

Supplementary wide-angle conversion lenses (left) are usually used with dome ports. The conversion lens may be built into the dome port system, or may screw into the camcorder lens.

Wide-angle conversion lenses (usually about 0.42x or 0.5x) are usually used with camcorder lenses and dome ports. The conversion lens widens the picture angle and reduces focused distance so the lens focuses closer than indicated on the focus scale.

Wide-angle lenses and dome ports give increased depth of field. On a bright day, everything from about one foot to twenty or more feet will be within the depth of field. This extended depth of field often hides incorrect focus settings, especially in bright conditions.

AUTOLOCK

As discussed in Chapter 4, you must turn the autolock off if you wish to override automatic camcorder controls with electronic or mechanical housing controls.

FOCUSING WITH DOME PORTS

In most cases, you will set the camcorder lens for the wide-angle zoom setting. You can usually only zoom partway toward telephoto. At full telephoto, the focused distance is beyond the virtual image in front of the dome port. The result will be blurry images.

Preset focus method. This is the easiest method. The camcorder lens is usually preset for manual focus and a distance specified by the housing manufacturer. However, instructions vary with different manufacturer's combinations of lenses and domes. Some manufacturers specify using the macro mode or adding a supplementary CU lens.

Autofocus with CU lens. Generally, you need to use a supplementary CU (close-up) lens if you wish to use autofocus. Specifications vary, so check the housing manufacturer's instructions. Warning: Some wide-angle lenses that screw into camcorder lenses are so heavy that the autofocus motor doesn't have enough power to function.

Macro mode. Some housing manufacturers specify setting the camcorder lens for the macro mode. This allows the lens to focus on the virtual image in front of the dome port. Focus by presetting for the distance specified by the housing manufacturer or by slowly adjusting the zoom setting while underwater. Because the zoom may be too fast for you to see the point of sharp focus, some manufacturers have added an electronic delay to the zoom control. Note: Autofocus usually doesn't function in the macro mode.

Full-range autofocus macro lens. These lenses work well with dome ports because they can autofocus on the small differences in the virtual image distances created by the dome port. You can leave the lens in the autofocus mode. Or, you can use autofocus to establish focus for a desired distance, and then reset for manual focus to lock the focus setting in place.

• • •

Because instructions vary with the many combinations of camcorder lenses, wide-angle conversion lens and sizes of dome ports, it is impossible to present one set of instructions that apply to all combinations. Therefore, general focusing procedures are given at the end of this chapter.

• • •

Dome Port Problems

The optical centers of the lens and dome port must be perfectly aligned. The front of the lens must protrude into the dome at the correct distance, and must be centered relative to the port.

For the lens-to-port distance, you have to trust the manufacturer. The optical center of the lens can shift when you zoom or change focus, so image sharpness can vary slightly with these settings. All you can do is experiment; this information isn't provided in owner's manuals.

For centering, look at the lens through the dome port, or remove the port and look at the lens, relative to the opening in the housing. If you see the lens isn't centered, you know that the system can't be optically correct. Sometimes you can use shims (rubber, Styrofoam, etc.) to adjust alignment.

The point of exact focus is slightly different at the center of the picture area than at the edges. In bright conditions, the automatic exposure control closes the aperture which increases depth of field. Thus, wide-angle depth of field hides differences in center and edge sharpness. However, if the aperture is wide open and the lens is focused for the central picture area, you may see a slight loss of sharpness in the corners.

How-To Summary
Wide-Angle Lens, Dome Port and Sunlight

1. Turn auto lock off.
2. Set white balance for outdoor (or automatic).
3. Attach color-correcting filter. (Remove filter for dark conditions.)
4. Attach wide-angle lens.
5. Set camcorder lens for widest zoom setting.
6 Set focus as per manufacturer's instructions.
7. Set for standby.
8. Shoot the subject.

How-To Summary
Wide-Angle Lens, Dome Port and Video Light

1. Turn auto lock off.
2. Remove filter and set white balance for outdoor (or automatic) if the video light is for fill lighting.
3. Remove filter and set white balance for indoor (or automatic) for wide-angle close-ups.
4. Attach wide-angle lens.
5. Set camcorder lens for widest zoom setting.
6. Set focus as per manufacturer's instructions.
7. Set for standby.
8. Turn video light on.
9. Shoot the subject.
10. Turn video light off.

Limitations of How-To Summaries

You may need to modify the how-to list to fit the controls your housing has and the manufacturer's instructions for your specific equipment. Selecting white balance is discussed in greater detail in Chapter 11.

···6···

EQUIPMENT MAINTENANCE

This is probably the most important chapter in this book. Saltwater is a tough environment for your video equipment, but a few precautions can minimize potential problems.

CAMCORDER CARE

Your camcorder doesn't like dust, moisture or excessive vibration. Place it inside a zip-lock bag for protective storage. In humid climates, drive out moisture with warm (not hot) air from a hair dryer before sealing the bag. In use, don't handle the camcorder with wet, sandy hands. When flying, wrap the camcorder in foam rubber or other shock-resistant materials.

Some camcorders show a warning symbol in the viewfinder if video heads are clogged. If not, look for streaks in the picture during playback. Special head cleaning cassettes will clean clogged heads, but check your owner's manual for specific recommendations. Clean video heads only when necessary. Excessive or improper cleaning could damage them.

Keep the lens cap on when the camcorder isn't in use. During use, a skylight filter over the lens acts as a transparent lens cap and has little effect on images.

Clean the main battery contacts, and the lithium battery and its contacts, with a pencil eraser and soft cloth. Remove the main battery during storage as it slowly drains even if the camcorder is turned off. The lithium battery can be left in place.

LENS CLEANING

The glass surfaces of camcorder lenses, close-up lenses and

wide-angle adapters sometimes need cleaning. You can buy lens tissue and lens cleaning fluid at most camera stores. For gentle wiping, I use a lens chamois or a Luminex Ultrafine Cleaning Cloth. Lens cleaning isn't preventive maintenance. Clean lenses only when they are dirty. Do not apply liquid lens cleaner directly to the lens. Apply the cleaner to lens tissue and then carefully wipe the lens.

CONDITIONING NICAD BATTERIES

For most reliable service, use nicad batteries until they are fully discharged, and recharge them fully before their next use. A nicad is fully discharged when the camcorder stops running, or when a video light loses its brightness. Warning: Discharging past these points can damage a nicad. (The polarity of one or more cells could be reversed.) When the nicad is fully discharged, remove it from the camcorder or video light and recharge it. If video light batteries are hot, let them cool before recharging.

Fully discharging nicads is a problem because you don't want to start a dive with a partially-discharged nicad. If you only have one battery, give it a partial charge between dives. If you have two, switch batteries. Either way, the used battery usually isn't fully discharged when placed on the charger.

To insure full discharge before an overnight charging, several nicad "conditioners" are available. These units have built-in circuitry that discharges the battery before giving it a full charge. You can make a discharger with resistors and/or small light bulbs, but you have to watch for the light to dim. Commercial dischargers shut off automatically.

Most underwater videographers discharge video light nicads by allowing them to burn down at the end of the last dive. If you place a video light in the camera rinse tank to finish the burn down, keep an eye on the light. If you forget about it, you can discharge the nicad battery too deeply and damage it.

Some sources recommend fully charging nicads before storage and recharging every month. Other sources recommend discharging nicads before storage. Because there is confusion, read

The nicad discharger/charger "conditions" a nicad battery pack by discharging and then recharging the battery. The charger shuts off automatically when the nicad is fully charged.

the owner's instructions for your particular battery. If storage instructions are missing, I'd opt for charging. After prolonged storage, I condition nicad camcorder batteries with three discharge/charge cycles on a commercial nicad conditioner. With nicads for video lights, I charge for the recommended time just before use.

NICAD MEMORY: FACT OR FICTION

Some nicad batteries remember short charge and discharge cycles. For example, suppose a camcorder battery is designed to power a camcorder for 40 minutes, with a full recharge time of 60 minutes. However, the user repeatedly runs the camcorder for about 20 minutes, and then gives the battery a 30-minute charge. The battery now "remembers" that it must only deliver 20 minutes of power before each 30-minute recharge. It

now resists accepting a full 60 minute charge and delivering a full 40 minutes of power. To break its memory pattern, fully charge and fully discharge the battery three times. When recharged for the fourth time, the battery will deliver its best performance. Because of age and deterioration, however, performance may not equal advertised specifications.

Other sources say nicad memory may have existed in the past, but doesn't exist with modern nicads. I believe memory varies from brand to brand. In my experience, occasionally fully discharging and recharging nicad battery three times seems to improve nicad performance.

MAINTAINING VIDEO LIGHTS

If your video light has a plastic shell which screws over the main body, loosen it during prolonged storage. When you remove this shell for battery replacement, examine the threads for debris and small plastic chips. When replacing the plastic shell, tighten just enough to seat the 0-ring. If you leave the battery inside the video light while traveling, place the battery on the non-operational position. I've seen a video light that melted down because the off/on switch was accidentally triggered during packing.

When changing bulbs, don't touch the bulb or polished inside of the reflector. Perspiration acids could etch the glass and reflective coating. If there is space inside the video light housing, store an extra bulb inside. Some lights have a special clip for bulb storage. If not, tape the bulb in place.

MAINTAINING THE HOUSING

The user-serviceable housing 0-rings are those that seal the main lid, removable lens ports and mechanical control rods which penetrate the housing. As always, start with the owner's manual for servicing instructions.

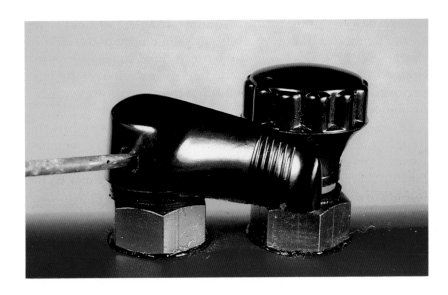

The screws securing some control knobs can be removed with a screwdriver. The control rod can then be pushed into the housing and removed for cleaning.

The disassembled control shaft can be cleaned and lightly coated with silicone grease.

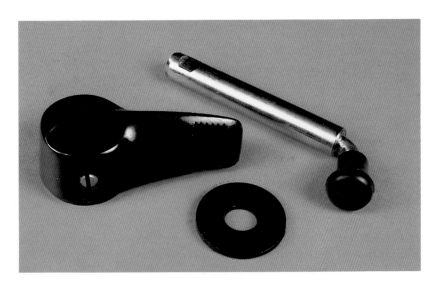

Some 0-rings for the main lid and lens ports can be easily removed. Wash these in water and detergent to remove accumulated grease and grime, then dry them with a soft cloth. If a main body 0-ring is cemented in place, don't pry it out. Wipe it clean with a damp cloth. If instructions call for silicone 0-ring grease, apply grease sparingly. If the 0-ring is merely pressed by one surface against another, it only needs a thin coating. 0-rings that slide, such as when a port is rotated, need a slightly thicker coating. Use your fingertips to feel for nicks or cuts as you apply grease evenly over the entire surface of an 0-ring.

Wipe the sealing surfaces of the housing and lid with a soft cloth, and clean 0-ring groves with the edge of a paper towel, cloth or Q-tip. Don't use spray lubricants on transparent plastic housings. After cleaning, inspect sealing surfaces for small pieces of lint, hair, etc.

Control rods that penetrate the housing (and activate camcorder controls by push/pull or rotation) can usually be removed for cleaning. Loosen the outer control handle, on the outside of the housing, and push the rod through to the inside. Use a Q-tip to clean the 0-ring inside the nut that screws into the housing. If the rod slides in and out of the housing significantly when the knob is attached, you can wipe and lightly grease the rod without removing it.

Loose rubber tips on the ends of control rods can jam camcorder switches. If a rubber tip falls off, the rod may scratch the switch or fail to make contact. Glue loose rubber caps in place. If lost, use tape to reconstruct a padded tip.

Clean out the inside of the housing with a cloth and portable vacuum cleaner. You'd be surprised how much dust and dirt accumulates in housings. If the lens port isn't removable, clean it by reaching inside with a soft lens-cleaning cloth.

Release tension on locking snaps during prolonged storage. For air travel, loosen or remove the pressure-release screw or plug to vent the housing. If the housing doesn't have a pressure release, remove the main 0-ring. You may fly many times without taking these precautions, but I've seen a dome port unseat because of pressure differences in flight.

Maintaining Metal Fittings

Metal fittings include clamps that hold the housing lid in place, the nuts and bolts that keep adjustable arms and brackets together, the handles which attach to the housing and the mounting shoes on the tops of housing handles. Before storage, unscrew, clean and lightly lubricate all removable fittings and handles. Otherwise, they will freeze in place with corrosion. If you remove the handles for air travel, insert the mounting screws into the handles and tape them in place. Then, tape the Allen wrench (hex key) to one of the handles so you can find it later.

Preparing for a Trip

1. Read all owner's manuals carefully.
2. Service all accessible 0-rings.
3. Charge all nicads. Replace old (one-year or more) lithium batteries.
4. Don't assume anything. Assemble the entire system and test it.
5. Make a written check list of all needed cords, chargers, spare bulbs, other parts and tools.
6. Make a list of steps needed to use the system–replacing pressure-vent plug; adjusting white balance, focus settings, shutter speeds, etc. Attach this list to the inside of the housing lid.
7. Label each charger with charging times. Label each nicad battery pack and videotape cassette with an ID number or letter.
8. Attach handle mounting screws, and their tightening wrench, to handles with duct tape.
9. Use white tape and a laundry marker to label each housing control, on the exterior of the housing. Indicate which direction the control is moved for the desired effect.
10. Submerge the empty housing in water to check for leaks after flying to your destination.

Coolers (such as a 48 or 54 quart Coleman) are great for transporting video gear. Place a layer of foam rubber on the bottom of the cooler, and pack rolled-up clothing around the housing and lights. Use duct tape to seal the cooler shut.

PART

··· 3 ···

SHOOTING TECHNIQUES

··· 7 ···

TAKING CHARGE OF YOUR CAMERA SYSTEM

*Shooting underwater video is easy at first. Just point the cam-
era, squeeze the on/off trigger and whamo! You're recording
images on videotape. It's easy, or so it seems.*

*When you watch your first results, you'll soon see there is
much more to shooting underwater video than simply point-
ing the camera at subjects. Jerky images on the TV screen will
jar your eyeballs, and fast pans can make viewers seasick.
You'll soon learn an important lesson: you must control the
camera rather than letting the camera control you.*

TAKE CONTROL OF YOUR BODY

The finest equipment money can buy, and the world's most
creative shooting plan are worthless if you have poor body
control. If your fins and feet are always moving, you can't
hold the camera steady. To gain steadiness and establish neutral
buoyancy, let's start with two basic body control drills:

The sky diver position. At a depth of about fifteen to
twenty feet (or whatever working depth you prefer), put your
body into the free fall "sky diver" position. While prone, ex-
tend your arms out to the camera holding position, with elbows
slightly bent. Then, extend your legs, with the knees slightly
bent and with your feet about one or two feet apart. You should
be able to hold that position–virtually motionless–for several
seconds, without using your hands or fins to maintain depth
or balance. Inhaling should make you rise slowly, but don't
do so. Rising could cause an embolism! Exhaling should cause
you to sink.

Use the "sky diver" position to test your buoyancy. Once your basic buoyancy is established, repeat this test while holding your video system.

Vertical with crossed fins. Position yourself vertically. Fold your arms across your chest and cross your fins. You should be able to maintain this position for several seconds without changing depth. If you inhaled, you would rise. When you exhale, you should start to sink.

Both of the above positions require little or no air in your B.C. Shifting air, or a lopsided weight belt, can throw you off balance. If you feel yourself tilt to one side during the dive, your weight belt has shifted and needs to be repositioned.

You may need to change weights for different depths, fresh water or seawater, diving attire (thin or thick wet suits), or if

In a vertical position, with fins crossed, you should be able to maintain your depth and position for several seconds.

video lights are added to the system. I always use the sky diver and crossed fin tests to adjust buoyancy whenever conditions change.

BALANCING THE HOUSING

The housed camera should be close to neutral buoyancy, and shouldn't tend to tilt in any direction. If the housing pulls you up or down, it will upset your body control. If it tilts forward or backward, it will fatigue your wrists, especially when

You should be able to hold a well-balanced housing with one finger on top if positively buoyant or one finger on the bottom if negatively buoyant.

you try to hold the housing with one hand.

During photo courses, I always ask students to place their housed camera in the rinse tank so we can check its balance before diving. To add weight, you can attach flattened fishing sinkers or pieces of sheet lead to the housing with duct tape. To gain buoyancy, tape small pieces of Styrofoam to the housing. If neoprene is available, make a sheath that fits over the light housing. The sheath provides both padding and buoyancy.

LEARNING VIEWFINDING

Some older housings only have a simple viewfinder frame mounted on the top. If you have one of these, it will take time to acquire a "feeling" for the picture area.

Most camcorders have electronic viewfinders, and the housings usually have accessory magnifiers to enlarge your view

of the viewfinder screen. If the magnifier is adjustable to your vision, make the adjustment while wearing your dive mask, especially if you have prescription lenses. Adjust it by rotating the magnifier and looking at the sharpness of the letters displayed on the viewfinder screen. Then, glue the magnifier in place to help you resist the temptation to change the adjustment for others. (You always forget to change it back.)

A major problem with electronic viewfinders is that you can't see subjects that are about to come into view. A fish suddenly appears in the viewfinder, and you abruptly jerk the camera to center it. When shooting moving subjects, it's often easier to use the electronic viewfinder to determine the size of the picture area and then sight over the top of the housing. Try holding the housing several inches in front of your facemask, with both eyes open. Aim by looking alongside the housing with one eye, and at the viewfinder with the other. This method works best if you're using a miniature TV/monitor for a viewfinder.

If you don't have a viewfinder magnifier, the electronic viewfinder is difficult to use with moving subjects. Most beginners tend to move their cameras around, searching for subjects while shooting. Instead, try sighting over the top of the housing for moving subjects and using the electronic viewfinder for stationary subjects.

LEARNING SIGNAL DISPLAYS

Signal displays—such as "end of tape," or "low battery"—may appear on the viewfinder screen. Read your owner's manual carefully and see which signal displays apply to underwater use. You can use plastic tape and a laundry marker to attach explanations of signal symbols to the rear of your housing.

LEARNING THE CONTROLS

Housings have one or more controls that engage mechanically or connect electronically to the camcorder. You must be

able to reach and operate the controls comfortably, without jiggling the camera while shooting.

Learn the positions and operational directions (forward, backward, etc.) for each control. Start topside, with the camcorder installed in the housing. Then have a practice session underwater. Shoot subjects at different distances, with different lighting conditions. Practice until you can find and operate each control by feel. This may take more than one session if the controls don't have a positive on/off feel. Develop the habit of frequently checking to be sure the camera isn't inadvertently recording when you think it is off.

● ● ● ────────────────────────────────

Let's go through the steps for a typical video dive. We will be using an 8mm camcorder in a housing that has a built-in wide-angle adapter and dome port. To keep it simple, we will be using natural light. We will proceed as follows:

1. **Service housing sealing surfaces.** *See owner's manual.*
2. **Test the housing.** *Before installing the camera, submerge the housing in a container of water to test for leaks. If it's going to leak, it doesn't have to be in deep water; it will leak just below the surface.*
3. **Preset controls.** *Review the how-to summaries in chapters 4 and 5. Beginners often do best when using as many automatic features as possible.*
4. **Place camcorder in housing.** *Do this carefully—you could bend control rods, pinch or break wires, and scratch or damage the camcorder. If the camcorder is on a mount that slides into the housing, look in the viewfinder as you slide the camcorder in place. If the camcorder isn't centered, you will see vignetting (rounding) in two corners of the picture area. If the lens is set for too wide an angle (short focal length), you will see vignetting in all four corners.*
5. **Close housing before leaving air-conditioned rooms.** *This eliminates condensation caused by temperature and humidity changes. In humid climates, you can remove moisture by blowing warm air (hairdryer on low) over the camcorder and inside the housing just before inserting the tape and sealing the housing. Trigger the camcorder to standby, record, back to standby, and to off, with the housing control, to test these functions.*

6. Test for leaks again. *After entering the water, hold the housing with the lens port pointing down. Raise the housing above your head and examine the port for water droplets on its inner surface.*

7. Have fun. *Hold the housing steady as you shoot the underwater action. Stay in the open—don't aim the camcorder at dark areas beneath ledges.*

8. After the dive. *Rinse the housing in fresh water. Dry your hands and head before opening the housing. Saltwater drops falling from your hair or running down your wrists can damage the camcorder. If possible, wait until you are back in your air-conditioned room. Caution: Don't use compressed air to blow off the housing; it could force saltwater past O-rings.*

● ● ●

FIFTEEN PRACTICE DRILLS

To learn how to handle your camera smoothly underwater, I strongly recommend that you master the 15 drills that follow. In each case, shoot at least 10 or 15 seconds while doing the drill. Then, during playback, evaluate how well you did the drill. Analyze each still shot for steadiness; your subjects should be rock-steady on the TV screen. Moving shots, such as zooming, panning or tilting, should appear smooth and natural on the TV screen. The drills follow:

1. Standing and kneeling. The goal is to hold the camera as steady as possible. Find a patch of sand and practice standing and kneeling on bottom as you aim the camera at a stationary subject.

2. The tripod brace. Your goal is to settle on a silty bottom without raising a cloud. Find a patch of bottom where you would stir up clouds of sand if you made unnecessary movements. Settle slowly in a prone position. Brace yourself on bottom with your fintips and the knuckles of your left hand. Look to see if you stirred up any sand.

3. The bipod brace. Start with the tripod brace position (#2, above), then reach up and add some air to your B.C. Your

An advanced variation of the tripod brace is to balance on fintips. This stance helps you avoid resting your body on delicate corals.

goal is to have just enough lift with the B.C. so you don't need to brace your hand on bottom. Your fintips are the "bipod."

4. Mid-water camera. Your goal is to hold the camera as steady as possible while shooting a stationary subject. Using the sky diver position, shoot a 10-second shot of a stationary subject. Then, from the vertical position with crossed fins, take another 10-second shot. After you've mastered buoyancy with crossed fins, you'll probably shoot with your fins slightly apart and pointed slightly outward.

5. The sinking/tilt zoom. Your goal is to slowly tilt the camera upward toward a stationary subject (such as the dive boat's swim step) as your body slowly sinks. Let some air out of your BC, then sink with your body in a vertical position with bent knees. Point one fin partly outward, and the other slightly back and downward. The angle of your fins helps you control your rate of descent.

6. The gliding zoom. Your goal is a smooth, slow change of image size during the shot. Topside videographers often use the zoom control to slowly change image size during a shoot. Underwater, you may zoom from wide-angle to close-up to direct attention to the main subject.

● ● ●

Many housings lack a zoom control or the control is awkward to use. Also, with a wide-angle lens and a dome port, zooming can upset the focus. This is why the gliding zoom is important. Start swimming toward your subject from beyond the desired shooting distance. Then, stop finning and slowly glide toward your subject as you shoot.

● ● ●

Practice the gliding zoom with slightly upward and downward angles as well as with a level approach. When gliding downward, exhale to decrease buoyancy. *When gliding upward, exhale to avoid an embolism!*

7. The circle around. Your goal is to see how far you can circle around your subject before losing body control. Start with a strong gliding zoom, but aim for a point beside your subject. Keep the camera aimed at your subject, and circle around the subject as you end the gliding zoom approach.

8. Follow a moving subject. The problem beginners have with moving subjects–such as a fish–is that they try to follow every single movement. Your goal is to follow the subject's general direction, not every twist and turn it makes.

9. The slow pan. Your goal is to practice smooth panning and to see what panning speed is best. Rapid, jerky panning will make your video unpleasant to view. Begin by kneeling or standing on bottom, facing the direction where the pan will end. Then, twist your upper body to face where the pan will begin. Start shooting and pan slowly as you turn your body to the ending point. By "winding up" your upper body first, then "unwinding" during the pan, the pan will be much smoother.

The mid-water camera—actually the "skydiver" position—allows you to shoot a steady scene from a mid-water position.

Once mastered, the gliding zoom is an excellent technique for zooming in for a closer view of a subject during a shoot.

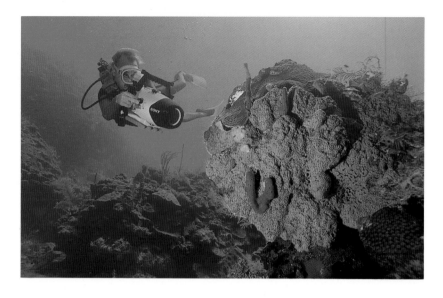

The combination of zooming toward, and circling around, adds movement and dynamics to static subjects.

Following a moving subject without unnatural camera movements is an important skill. Follow the trend of the subject's movement, not every fluctuation.

● ● ●
──

Pan first at the speed you think you should pan, then again at half that speed. When you view the tape later, you'll see that the slow pan is usually better.

Avoid the "indecisive pan." Once you start panning, don't back up to show something again. The exceptions being if the subject is extremely important, or if you are simulating a diver's searching view.

──
● ● ●

10. The parallel pan. Your goal is to keep a moving subject centered while swimming along with it. To practice, shoot a 10-second shot of another diver as you both swim in parallel. You and your subject must both swim slowly because the drag of the camera will slow you down and tends to turn your body. Stay slightly ahead of your subject.

11. The overhead reverse. Your goal is an eye-catching shot that shows a diver (or fish, etc.) approaching, passing overhead and then swimming away. Stand on the bottom. Aim the camera at a distant diver who will swim over you and begin shooting. Tilt upward to follow the diver's movement and rotate your body 180 degrees as the diver passes directly over you. Continue shooting as the diver swims away. Practice with the diver passing directly over you, and again with the diver swimming slightly to one side of you. Don't exhale when the diver is overhead unless you want your bubbles to be in the scene.

12. Entries and exits. Your goal is to start and stop a shot smoothly. To practice, aim your camera at a preselected background and start shooting. Have your dive partner swim into the scene, stop, look at something, and then swim out of the scene.

13. The swim through. Your goal is to show a diver's view as he or she swims along the seafloor. Aim the camera ahead of you as you swim along the bottom. The main point of this drill is to keep the camera steady while you use your fins. Swim slowly so the camera doesn't rock.

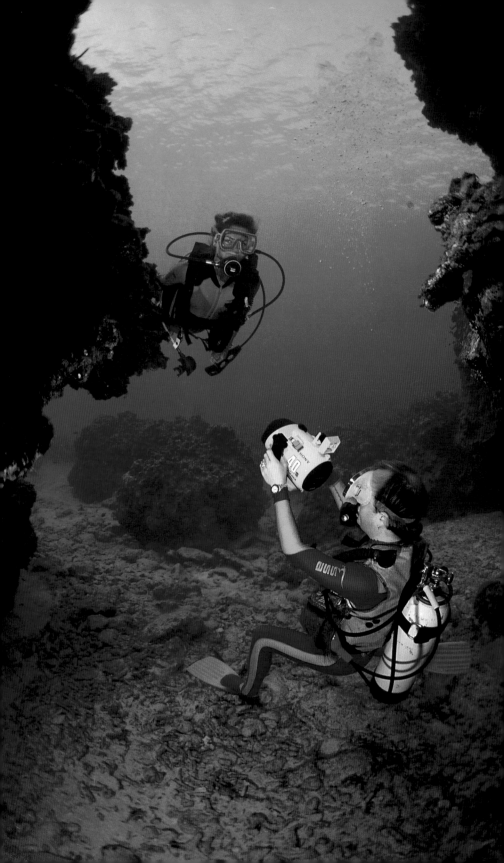

The self-pan should be used sparingly and briefly to make it more interesting.

14. The self pan. Your goal is to create a moving background behind your own image. Hold the housing at arm's length, aimed directly at you. Twist your body (as in #9, the slow pan) as you aim the camera toward your face.

15. The self scene. Your goal is the shoot yourself entering and exiting a scene. Rest the camera on dead coral or wreckage, level it and turn it on. Then, swim around into the camera's view. Look at, or relate to, something in the scene, then swim out of the camera's view. Ideally, you should use a tripod.

COMBINE THE DRILLS

Try using combinations of two or more drills, such as panning and tilting while standing or kneeling, or while ascending or descending.

● ● ●
Practice pays dividends. Not only will your camera handling become much smoother, but the increased variety of camera angles will make your underwater videos much more interesting to view. Later, you might want to edit some of your practice shots into your video stories.
● ● ●

The overhead reverse is a simple, yet dynamic shot. The secret is the timing: when to start and end the reversal. Practice with subjects below you as well as above.

··· *8* ···

PROFESSIONAL
SHOOTING TECHNIQUES

*Now that you're started in underwater videomaking, you'll
find yourself watching TV shows and movies from a differ-
ent viewpoint. You'll notice how professionals use repeated
combinations of three basic shots: the LS (long shot), MS
(medium shot) and CU (close-up shot).*

*Once you see how the LS, MS and CU can be used as
"building blocks," you'll begin adding professional shooting
techniques to your underwater video movies.*

THE LONG SHOT (LS)

The LS is usually a wide-angle shot that shows the overall
view of the scene. The camera-to-subject distance and pic-
ture area will vary with the size and importance of the sub-
ject.

The superstructure of a sunken ship in Truk Lagoon, for
example, requires a larger picture area for an LS than an ar-
tillery piece secured to the deck of the same ship. An LS showing
an eel's lair in the wreckage would cover even a smaller pic-
ture area. The secret of using the LS effectively is to use a
picture area that shows your subject in its natural setting.

The LS has four main purposes: to set the stage, to re-es-
tablish a scene or action, to end an action sequence, or to
provide a transition to a new location. Let's examine each of
these purposes in detail:

Setting the stage. The LS is a natural introductory shot.
It shows the overall view of the scene. It shows the terrain,
weather, visibility if underwater, and may include your main

characters. The introductory LS sets the stage for the action that will follow.

Suppose that you are shooting a video diary of a trip aboard a liveaboard dive boat. You could use an introductory LS showing the entire vessel. This shows the viewer the vessel's appearance and size, as well as weather and sea conditions. Then, to introduce the underwater portion of your video movie, you might use an upward LS showing the dive boat above, with divers coming down. The viewer now has an indication of visibility and knows that some underwater adventure is about to begin.

A LS showing an upward view of divers descending introduces viewers to the underwater action which will follow.

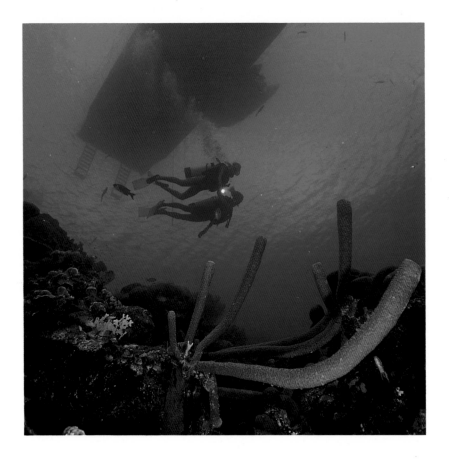

Re-establishing the location. After a series of close-up views, use another LS to remind the viewer of the location. If you are shooting topside close-ups, for example, a brief LS of the entire vessel reminds the viewer where the action is taking place. Likewise, if shooting close-up shots of an eel's face, use an occasional LS of the eel's body protruding from its lair to remind the viewer of the overall scene.

● ● ● ───

Re-establish whenever you add something new to the scene. If a diver joins a fish feeding sequence, for example, use a LS to show him joining the group. Then, you can go back to fish faces. ● ● ●
───

Transitions to new locations. Use the LS to bridge the gaps between different locations, different dives or different activities during dives. For example, an underwater LS showing divers heading up to the surface can be followed by a topside LS of the divers on the swim step. Together, the two long shots provide the transition from under the sea to topside. If for another example, you show divers leaving one part of a submerged wreck, a transition LS of the divers swimming along the submerged hull emphasizes that the divers are changing location. This transition LS helps you avoid "jump cuts," where a diver suddenly appears in a completely different location.

Ending the action or story. The LS can be used as a resolving shot to end either the present action or the entire story. For example, if you are showing divers feeding fish, you can end with a LS of the divers swimming away from the fish. This ends the present action. To end the story, you can use another LS of the divers swimming up to the surface.

THE MEDIUM SHOT (MS)

The MS shows only a selected part of the total scene introduced by the LS. The picture area of the MS is relative to subject size and the action you wish to emphasize. An MS of a diver

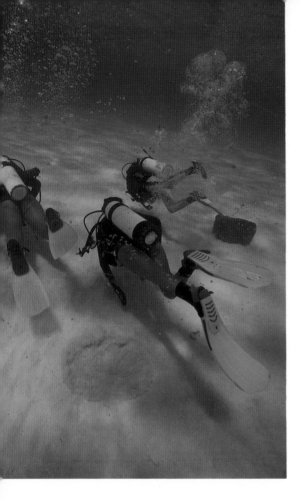

A LS of divers leaving ends present action and prepares the viewer for an ending or a transition to another segment of your video movie.

is usually framed from the waist to just over the top of his head. An MS of a hermit crab could barely include the entire crab. The basic uses of the MS are:

Identifying specific subjects. After the introductory LS sets the scene, the MS identifies specific subjects or actions. If the LS showed two distant divers, for example, each individual diver can be introduced with a short head–and–shoulder MS.

A transition from LS to CU. If you show a LS of a diver approaching a wreck, and follow with a CU view of the diver's hand touching an artifact, this change in perspective is too abrupt. One or more MS views of the diver reaching for arti-facts smooths the change. The MS provides a transition from the wide–angle to the close–up view.

The MS is your action shot. Whether you are showing divers searching for shells or artifacts, feeding fish, or just clowning around, the MS is your key shot. The MS emphasizes action.

THE CLOSE-UP SHOT (CU)

The LS and MS shots are the "yellow brick road" that leads your viewer to a CU (close-up) view of the main subject or action. However, the designation "CU" is misleading! A CU of a whale's face would show a much larger picture area than a LS of an eel in his lair. Picture areas for LS, MS and CU shots are determined by the subject's relative sizes and the purpose of the shots taken. The main uses for CU shots are:

CU shots pinpoint the action. Once the LS has set the stage, and the MS has identified the actors, the CU pinpoints the action. The CU shows the artifact or shell in the diver's hand, the grouper's face as he begs for food or the delicate tentacles of an anemone.

The CU adds interest and variety. Think of your first underwater video. You probably used nothing but LS and MS shots. For most viewers, the video was probably boring to watch, especially if divers were shown watching or reaching for small subjects that the viewers couldn't see clearly. Thus, the addition of CU shots between MS shots adds interest and variety.

The CU as an introduction. Imagine that you are shooting a CU of an anemone. You pull the camera back slightly and tilt upward to a LS of an approaching diver. The diver can approach the anemone, or can angle off to another subject. The diver's destination doesn't matter; you've introduced the viewer to the scene.

When shooting a series of CU shots, use an occasional MS or LS to break the monotony and re-establish the general view

of the subject for the viewer. For example, if a sequence of CU, CU, MS and CU shots is long, add an occasional LS to re-establish the overall scene for the viewer.

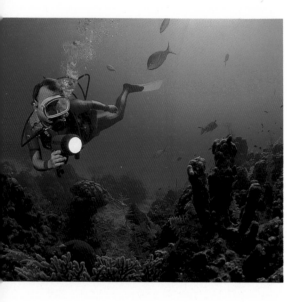

This introductory LS sets the scene—a diver approaches a set of tube sponges.

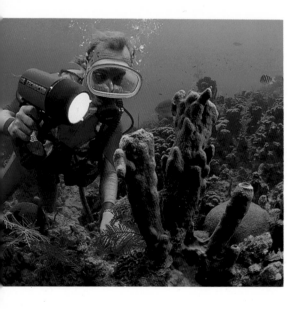

The MS gives the viewer a closer view and identifies the diver.

The close-up shot of the sponge shows the viewer the diver's view.

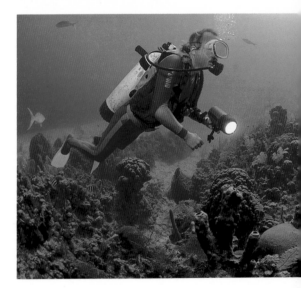

The ending LS resolves the present action. The diver leaves for a new underwater adventure.

The Secret Is Sequence

Now that you've been introduced to the three basic shots, the LS, MS and CU, let's see how these shots can be arranged in your video movies. From now on, think of these shots as "building blocks" that you can arrange in any order to create action sequences.

The LS, MS, CU and LS pattern. This basic pattern mimics the way we think and view a scene. We start with the overall view, identify specific subjects and then concentrate on a single subject or action. We usually end with a quick overall view to re-establish the location and resolve the sequence. You can use the LS, MS, CU and LS pattern again and again in your video story. Watch for this basic pattern–it's often used in movies and television shows.

Varying the pattern. You can, however, vary the LS, MS, CU and LS sequence. You can begin with a CU and move to an MS or LS. You can start with a LS and then alternate MS and CU shots. You can arrange the three basic shots into any pattern that enhances your video movie.

Timing Your Shots

Good timing enhances your sequencing techniques, but is often overlooked by beginners.

When to start and stop the camera. Videographers who do extensive editing sometimes leave the camera on. They edit out the best scenes later. Sport videographers, however, often prefer to edit in camera. They shoot their shots in sequence and do minimal editing. The safest technique is to start shots early and end shots after the action ends.

Shot length. When editing in camera, avoid single shots lasting more than about 15 seconds. Several shots–three to

five seconds each—will be more exciting to view than a single 15 or 20 second shot. To see what I mean, watch the evening news. Even if the newscaster or weatherman is on camera for up to 30 seconds at a time, notice how they keep changing camera angles and image sizes. No single shot—unless it is extremely interesting—will keep a viewer's attention for more than about 10 seconds.

THE GOLDEN RULE

This chapter can conclude with the "golden rule" of video movie making: Whenever you start a new shot, change the image size, change the camera angle, or change both image size and camera angle.

● ● ●

When editing in camera, I turn the camera on and off between most shots. This allows me to change distance, zoom for a different image size, or change the camera position without unwanted camera movement. You can, however, blend shots together. As examples, when we discussed starting with a CU of an anemone and then tilting up to a LS of a diver, we blended the CU and LS together. Likewise, we could use the gliding zoom to blend from LS to MS or MS to CU.

● ● ●

··· 9 ···

HOW TO ADD
INTEREST AND VARIETY

*With just three shots, the LS, MS and CU, as building blocks,
you can now arrange these basic shots into any logical or-
der. Enhance the three basic shots with the cut-in, cut-away
and overlapping action shots, and the technique of compress-
ing time, and your videos acquire a professional flair.*

USING THE CUT-IN

The cut-in shot is simply a CU or ECU (extreme close-up
shot) that cuts directly to an important part of the ac-
tion. For example, suppose you shoot an MS of a diver rais-
ing his console and looking at the depth gauge. Then, you
move in for a tight CU that shows the diver's view of the gauge.
This cut-in CU of the gauge helps the viewer identify with
the diver because you, the videographer, have shown the diver's
view of the gauge. Your next shot could be another MS showing
the diver lower his console. If you arranged these shots into
a shooting script, it would look like this:

MS: Diver raises console; looks at depth gauge.
CU: Cut-in shot to depth gauge.
MS: Diver lowers console.

You can use the cut-in shot in many ways. If the divers are
feeding a swarm of fish, put the camera right into the swarm
and shoot a short CU of the fish taking the food. If your model
is a photographer, move in for a tight shot showing their hands
on the controls as they make camera adjustments.
 The cut-in differs from a regular CU in that the cut-in pin-

points some small facet of the action that you might not normally shoot.

USING THE CUT-AWAY

The cut-away is a special CU shot. It cuts to a secondary action related to the main action. For example, let's build on the diver and depth gauge example used above. Take a moment and think about the following shot list (shooting script):

LS: Two divers are kneeling on a sandy bottom.
MS: Male diver raises his console· looks at depth gauge.
CU: Cut-in shot to depth gauge.
CU: Cut-away to female diver's face; she looks at gauge and nods.
MS: Male diver lowers his console.
LS: Both divers swim out of frame.

Let's examine the above sequence of shots and imagine just how they would appear on a TV set:

- The introductory LS set the scene. The two divers are kneeling on a sandy bottom.
- The MS shows that the male diver is concerned about his air supply. He raises his console to check the pressure. The viewer wonders how much air he has.
- The Cut-in CU lets the viewer see gauge. (The viewer has now "joined the dive.")
- The Cut-away CU to the female diver's face shows that she is also concerned.
- The MS shows that the male diver is finished looking at the gauge. At this point, he should give an "O.K." sign to his buddy.
- The ending LS ends this sequence and prepares the viewer for the next LS that will introduce the next phase of the dive.

Two divers swim into frame, then kneel on bottom. The viewer wonders what
action will take place.

Move in for a MS to identify the action. The male diver shows his console to
his companion.

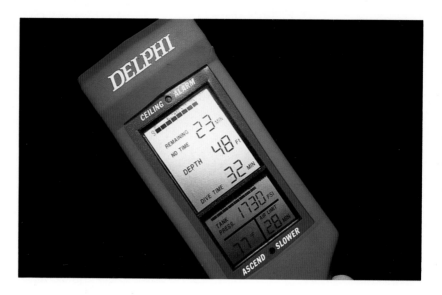

The cut-in shot to the console builds interest because the viewer can read the console display. Photo: Mike Mesgleski.

Cutting away to the female diver's face adds variety to the sequence.

A MS to LS shot moves the divers out of frame and ends this sequence.

●●● ───────────────────────────────

Just the simple act of checking a pressure gauge can be made interesting by using the LS, MS, CU and LS sequence. The addition of the cut-in and cut-away CU shots add variety and interest to the basic sequence. The cut-away adds another view to your visual presentation. Rather than just showing a diver looking at his pressure gauge, you've made this important safety procedure a special event.

─────────────────────────────── ●●●

The subject of the cut-away should usually be a subject that has already been introduced to the viewer. In the above example, the viewer had already seen the female diver in the introductory LS. Thus, the cut-away CU of her face won't confuse the viewer. Cut-aways can be used to create suspense or reveal simultaneous action, as follows:

The cut-away and suspense. You can use cut-away shots to build suspense. The idea is to let the viewer "in on a secret" that the divers don't know. For example, let's continue the action with the same two divers used in the previous ex-

amples. They ended the last sequence by swimming out of frame. Let's start the next sequence with them swimming into a new scene–a large patch of corals. The divers swim into frame and start searching for something in the coral:

LS: Both divers swim into view, stop, look at coral.
CU: Cut–away to eel's face peeking out of crevice.
MS: Tight shot of divers looking in crevices.
MS: Female diver points at something.
CU: Eel looking out of lair.
CU: Cut–away to female diver's face.
CU: Cut–away to male diver's face.
CU: Close-up of eel.
MS: Divers looking at eel.
LS: Divers wave "good bye" to eel. Swim away.

The first cut–away (to the eel) let the viewers see the eel before the divers saw it. This was a "plant." We planted a clue to cause the viewer to wonder, "Will the divers see the eel?"

● ● ● ─────────────────────────────────────

You're probably thinking, "If I had the chance to videotape an eel, I wouldn't be fooling around with all those cut-aways to divers' faces, I'd just shoot the eel!"

But once you had the eel on tape, couldn't you shoot the other scenes later and edit them into the sequence? This is the difference between "pointing and shooting" and creative underwater video-making!

─── ● ● ●

Cut–away to simultaneous action. Suppose you want to keep the viewer interested in two separate actions that are occurring simultaneously. For example, assume that your video is about a group of divers boat diving. Most of the divers are below, but a couple of notorious "chow hounds" decide to stay topside to guard the lunch.

Most of your shots will be of the underwater action, but you decide to inject some short cut-away shots of the two hungry divers in the boat. The first cut-away shows one shrugging his shoulders and reaching for a sandwich. The second

cut-away shows both divers reaching for sandwiches. The last cut-away shows them finishing the last of the lunch.

What have these cut-aways done for you? First, they added interest by mixing the underwater scenes with what was happening topside. Second, they planted a question: What revenge will the other divers seek when they return to the boat and find that the lunch has been eaten?

OVERLAPPING ACTION

An overlap joins two different views of the same action. You shoot the beginning of an action from one viewpoint, and then shoot the end of the action from another viewpoint, usually with a side view. For example, you shoot an outside view of a diver entering the open hatchway of a sunken vessel. Then, you go inside and shoot the inside view of the diver coming through the hatch. Note: The diver must swim through the hatch twice. The diver poses for the outside shot, and then again for the inside shot.

The first half of an overlapping action sequence: the diver approaches and swims into an open hatchway. Photo: Mike Mesgleski.

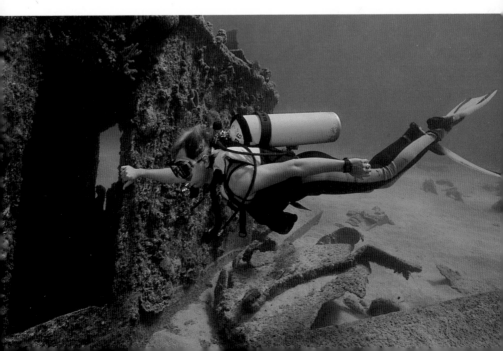

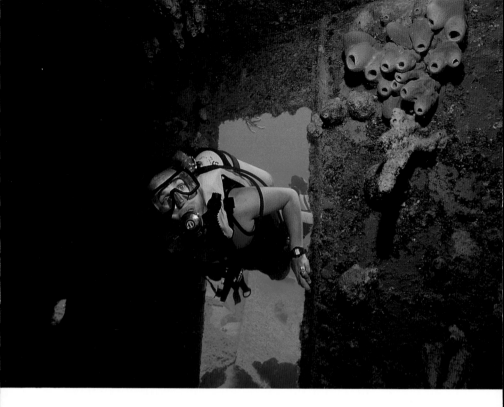

The second half of overlapping action: an inside view of the diver entering the hatchway. Photo: Mike Mesgleski.

The overlap adds interest two ways: the viewer sees the action from a new viewpoint, and the overlap also allows you to cross the "magic line." (Crossing the magic line is discussed in the following chapter.)

● ● ●
You don't need a sunken ship to shoot overlaps. You can use exterior and interior shots of divers entering underwater caves, or underwater and topside shots of divers entering or leaving the water. Overlaps are easy to shoot and give your videos a professional look.
● ● ●

COMPRESSING TIME

This technique allows you to join scenes together in a way that implies that time has passed between the scenes. For example, suppose that you are leaving for a diving vacation. You want to start the video at home, but wish to move on to your dive destination quickly. Your shooting script might begin as follows:

LS: (At home.) Spouse carries item to suitcase.
MS: (At home.) Opens suitcase, puts item inside.
CU: (At home.) Shuts suitcase, closes latch.
CU: (At home.) Cut-away to spouse's face, wipes brow.
CU: (At resort.) Opens latch, opens suitcase.
MS: (At resort.) Takes item from suitcase.
LS: (At resort.) Places items on bed.

In the above example, you started with a LS to establish the location as your home. The MS and CU show that you have finished packing for your trip. The CU cut-away is a distraction shot to strengthen the transition from your home to the resort. Then, you reverse the order of shots to show that you are unpacking at the resort. You've compressed time; you've jumped from home to resort without losing visual continuity.

Now, it's time to leave the room and acquaint the viewers with the resort. You can use an overlap to make this transition. To continue the above example, let's add the following two shots to the shooting script:

LS: (Inside view.) Spouse walks to door and exits.
LS: (Outside view.) Spouse walks out of door.

Your subject must cooperate if you shoot an overlap. In the above example, your spouse must walk through the doorway twice. You are now free to shoot a new LS to introduce the next part of your video story.

··· 10 ···

DIRECTIONAL CONTINUITY AND THE TV SCREEN

Directional continuity, as used in this chapter refers to two ideas: the direction action flows across the TV screen, and how changes in this direction strengthen or weaken directional continuity.

If you also shoot 35mm slides, remember that shooting for the TV screen is different than shooting for the larger 35mm slide show screen. You must change your techniques to fit the smaller TV screen.

SCREEN DIRECTION

Screen direction refers to the direction that movement and action flow across the TV screen. Most of us are accustomed to left–to–right eye travel because this is the way we learned to read. Left–to–right eye travel seems comfortable. Conversely, right–to–left travel implies something is different or has changed. While we may not actively think about this, the feeling is there. To see how screen direction can affect the mood of your underwater video, think of the following four examples:

Beginning a scene. If you begin a scene with divers entering the picture from left to right, the action seems natural. (Think of all the old cowboy movies you've seen. Didn't the good guys usually enter the scene from the left?) If the divers are continuing the dive after the first action sequence, have them exit the scene left to right; then, have them enter the

following scene from left to right again. Later, to end the action, showing them swim away from right to left seems natural. They are returning to where they came from.

Adding a character. To add a new character after the story line has begun, bring the newcomer in from right to left. This implies that something new is happening. (When the bad guy approached the cowboy hero, didn't he usually approach from right to left?) If you write the newcomer out of your script, take him out left to right (back to where he came from). For another example, suppose two buddy teams are diving separately, but will meet in your video movie. If buddy team "A" entered the opening scene from left to right, and buddy team "B" is brought in from right to left, the viewer is prepared for the meeting of the two teams.

Changing location. For a definite change of locale, have your divers exit the old location right to left (assuming they entered left to right). Then, start the new scene with them entering left to right.

Introducing a new subject with left-to-right action appears natural, but isn't an ironclad rule you must always follow.

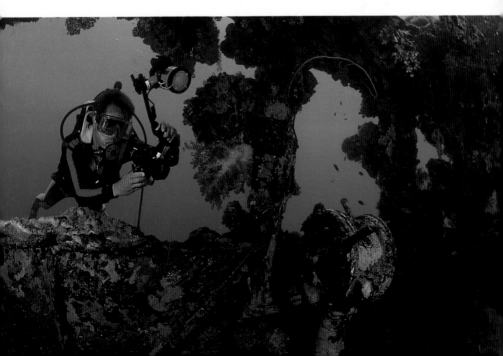

A new idea. Starting with right to left action implies new-ness. The feeling imparted is, "This is gonna be different." (When you watch new car commercials on TV, notice how often the new model rolls in from the right.)

The above example shows how the "starting from the left technique" isn't cast in stone. You start from either direction, depending on the mood you wish to create. Or, you can start or end a scene with the divers in the picture area.

CROSSING THE MAGIC LINE

The "magic line" is an imaginary line that passes parallel through your subject, much as a horizon line appears to pass through distant subjects. As long as you (the underwater videomaker) stay on your side of the imaginary line, screen direction flows normally. If you cross the line abruptly and take another shot of the same subject, screen direction is abruptly reversed.

● ● ●

An abrupt change in screen direction breaks visual continuity. For example, suppose that you shoot a LS or MS of a diver pointing his camera at something to the right of the screen. You decide that the background is unattractive, so you cross over the diver's other side and take another shot. These two shots, joined abruptly, will be confusing when viewed on a TV screen. The viewers see the diver looking to the right. Then the image is suddenly reversed—the diver is now looking to the left.

● ● ●

One or more transition shots may be needed to cross the line smoothly. For example, your first shot shows a photographer pointing his camera to the right. You move in for the transition shot over the photographer's shoulder and then, cross the line to shoot the photographer from the other side. To smooth the transition from one side of the line to the other, you could add a CU cut-in to distract the viewer from the change in screen direction. Consider the following sequence of shots:

LS: View of subject facing left to right.

MS: Tightly framed over–the–shoulder shot, close to the line.

(Cross the line.)

CU: Cut–in to subject photographer's face.

LS: View of subject facing right to left.

Let's analyze the shots listed above:

- The introductory LS shows a side view of an under-water photographer. He is aiming his camera from left to right. You don't want this viewpoint. You want to cross the line and shoot the photographer/model from the other side.
- The MS is the transition shot that allows you to cross the line.
- The CU is the distraction shot that helps mask the change in screen direction.
- The ending LS establishes the new viewpoint.

You start with a left-to-right shot of a diver photographing a group of fish, but wish to shoot the diver from the other side.

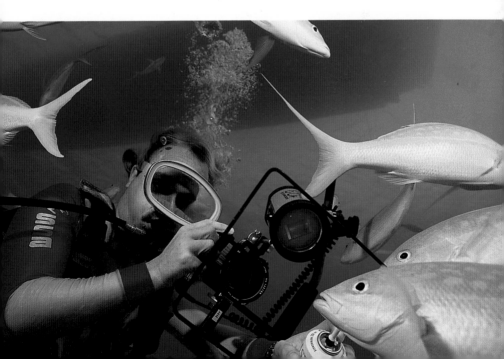

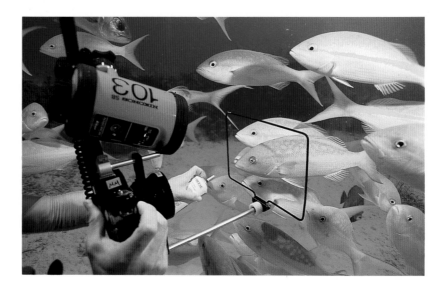

As the first transition shot before crossing the magic line, you move for an over-the-shoulder shot.

The CU cut-in to the photographer's face distracts the viewer's attention from the change in screen direction.

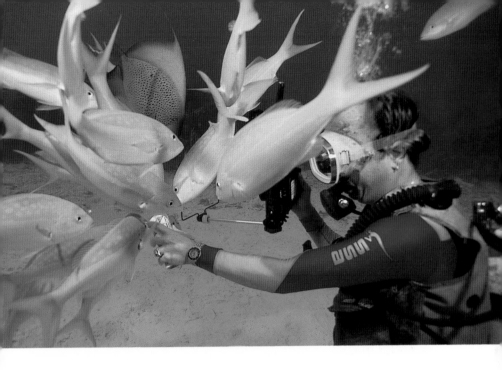

You have now crossed the magic line and show the photographer facing right-to-left.

● ● ● —————————————————————————
Use intermediate shots, such as cut-ins to your subject's face, or cut-aways to marine creatures or other diver's faces. These intermediate shots distract the viewer's attention from changes in screen direction and help you cross the magic line.
————————————————————— ● ● ●

There are exceptions. You can cross the magic line freely in the following situations:

The map shot. If you start with a downward LS, which shows the relative positions of your subjects, you can usually cross the line at will with subsequent MS and CU shots.

Fast cuts to fast action. When shooting fast action, you can usually cross the line once the overall scene is established. Use an occasional LS to re-establish the scene.

No directionality is implied. When shooting a montage of random views without any strong indications of screen direction, you can usually ignore the magic line.

After shooting a map shot that shows the respective positions of your subjects in a scene, you can cross the magic line freely. Photo: Mike Mesgleski.

The diver's view. If you show a diver looking at an object, you can cross the line to show the object from the diver's viewpoint.

• • •
─────────────────────────────────

Be sure to think of the magic line whenever movement—actual or implied—occurs. Once your subject looks or points in any direction, a magic line is created or changed. If you are cutting back and forth between two simultaneous actions, you may have two or more magic lines to contend with.

─────────────────────────────────
• • •

SHOOTING FOR THE TV SCREEN

Most home TV sets have viewing screens that are much smaller than screens used for showing 35mm slide shows (usually 30 x 40 inches, or more). Thus, you must think of the smaller TV screen as you shoot. Images that would be large and sharp in

a slide show will appear much smaller and harder to view on the smaller TV screen.

To compensate for the smaller TV screen, shoot scenes tight; fill the picture area with your subject. Shoot tighter than you would for a 35mm slide show. While you may use an ELS (extreme long shot) to establish a location, shoot following LS and MS shots as close as you can. As examples, a video LS may show the same picture area as a slide show MS, and a video MS as much as a slide show CU. The video image must fill the TV screen to give the viewer a clear view of the subject.

Filling the TV screen with a subject requires special techniques that will seem unnatural at first, especially to divers posing for you. Consider the following guidelines:

Pose close. Pose divers closer together than they would normally be. For a LS, they should be within touching distance. To enlarge their images, you can amputate at knee level. For an MS, you can overlap shoulders. For a CU, use a head and shoulders view. To see how tight these shots can be, watch the LS and MS shots of the weatherman, and the CU shots of the newscaster on the evening news.

The divers are too far apart, not facing the camera and not showing the viewer what they are examining.

*Pose divers close
together and angled
toward the camera, and
show the viewer what
the divers are
examining.*

• • •

*Getting close will seem unnatural to your diver models because each
will tend to maintain a normal topside distance from the other.
This normal distance, however, would force you to use a larger
picture area, which would make their images appear smaller on
the TV screen.*

• • •

Working with wide-angle perspective. If you want to
show a diver behind a large sponge, and wish to keep the
diver's image large relative to the sponge, the diver must be
close to the sponge. Otherwise, wide-angle perspective makes
the near sponge appear closer and larger than the diver. Even
if you wish to show a distant diver behind the sponge, the
diver must be closer than you would expect.

Eye contact. If a diver is holding and examining an ob-
ject, such as as docile fish, have her hold it about six inches
from her face. This will seem strange to the model, but al-
lows you to get closer and it will look better on the TV screen.
If the diver views the fish from the normal distance of one or
two feet, their images may be too small for easy TV viewing.
The diver's eye contact with the fish is also important. If the
diver focuses her eyes on the fish, she will appear cross-eyed.
Thus, have your model look toward the fish, but focus her
eyes a couple of feet past it.

*Close-up subjects should be close to the model's face, and the model should
focus her eyes beyond the subject to avoid appearing cross-eyed. Photo: Wayne
Hasson.*

··· 11 ···

EFFECTIVE
VIDEO LIGHTING

The Japanese tank was resting on the sunken freighter's main deck, at a depth of 117 feet. Because the tank was beyond the range of my video lights, this would be a sunlight shot. As I squeezed the on/off switch, I wondered if the video images would show enough detail.

WHITE BALANCE

The white balance control "tells" the camcorder to react as if whatever light source you are using is white. Thus, all colors should appear natural in your recorded images. Most camcorders have four basic white balance settings:

Outdoor (sunlight). Use the outdoor setting when shooting with sunlight, or if a video light provides fill lighting only.

Indoor (artificial light). Use the indoor setting if a video light provides most of the lighting. Also, use indoor white balance if you are shooting with sunlight, and a reddish filter, at depths less than about 12 feet.

Automatic white balance. The automatic white balance systems of the newest camcorders work quite well. You can use automatic white balance all the time to avoid confusion when mixing sunlight with video light. In addition, you can also use automatic white balance when shooting at night with video lights.

Hold white balance. You may be able to manually adjust white balance for specific conditions if your camcorder and

housing have compatible controls. All you need is a white target, such as a dive slate. The basic procedure follows:

1. Set for automatic white balance.
2. Set for standby. (Some camcorders may need to be triggered to the shooting mode–check owner's manual.)
3. Aim the camcorder at a white target which fills the central picture area.
4. After about fifteen seconds, automatic white balance should adjust to the lighting conditions of your target.
5. Switch to hold light balance.

Because the procedure may vary slightly with different camcorders, check the owner's manual. You may not be able to use the hold white balance with your underwater system.

CLEAR WATER AND SUNLIGHT

You don't need a video light for subjects illuminated by direct sunlight. If you have clear water and a sunny day, there is adequate light for video down to 100 feet or more. My video of the Japanese tank was great!

You can videotape large scenes with sunlight at depths exceeding 100 feet. Use the outdoor or automatic white balance setting and remove the reddish filter.

You can shoot underwater video with sunlight only, in Belize, Grand Cayman, Hawaii, the Virgin Islands, Truk Lagoon and many other places. A video light will sharpen details and enhance colors in the foregrounds of close shots, but can't reach out for your extreme long shots. As a rule of thumb, if you can see a distant subject clearly, your camcorder will record an acceptable image. The LS image will show the color cast of the water (blue, green, etc.), but that's the natural color of your background. Work with it.

FILTER FOR COLOR

To brighten colors in bluish water, use the reddish UR/PRO filter (or the reddish filter supplied by housing manufacturers, not the topside CC30R filter). For greenish water, use the UR/PRO GR (green) filter. The filter screws directly into the accessory threads at the front of the camcorder lens. With some housings, the filter attaches to the outside of the housing, in front of the lens port. With others, the filter may be inside the housing, with a control to flip it in and out of position. The reddish filter's effectiveness varies with depth, as noted below:

Shallow water. At about 15 feet or less, set the white balance for outdoor. Don't use the color-correction filter. If the filter is in place and can't be removed, and the housing has a white balance control, set the white balance for "indoor." If you use the filter in shallow water with the outdoor setting, the images will be too reddish.

Medium depth. The filter works best between about 15 and 60 feet, with the camcorder white balance set for "outdoor." The filter significantly enhances color.

Deep water. Below about 60 feet, the filter loses effectiveness. Removing it increases the amount of sunlight reaching the camcorder lens by about one f-stop. The additional light

improves picture quality and increases depth of field by about 25 percent.

Sunny Skies and Contrast

Direct sunlight creates contrast between sunlit and shadow areas. These high contrast areas can cause problems because they are difficult for camcorders to record evenly. Bright areas, such as the bright surface, a tunnel opening, light skin or colorful dive gear, tend to burn out. Burned out areas will appear orange or yellow on the TV screen.

Going below 35 or 40 feet diffuses strong sunlight and reduces the contrast range, but you can still get burn-out with upward camera angles. Getting below the plankton and suspended particles often found in the first 20 feet also helps sharpen video images.

When shooting upward views of a dive boat on sunny days, get in the shadow of the boat. Position yourself so the sunbeams radiate around the boat, or from one side. If the sun is in the scene it may burn out as a yellow or orange patch in the picture.

If you plan to shoot upward shots of dive boats, walls or coral formations on bright days, take one or more of these precautions:

Increase shutter speed. The goal is to prevent sunlight from overpowering the automatic exposure control.

Close the iris. Adjust the manual iris override control to decrease the lens aperture. This decreases overall image brightness.

Group your shots. Whenever possible, try to group your high-contrast shots so you can increase shutter speed and close the iris ahead of time. The safest technique, however, is to avoid high contrast scenes unless you absolutely need the shot.

● ● ● ────────────────────────────────────

Some camcorders tend to overexpose underwater scenes. Experiment with reducing exposure by closing the manual override control to close the iris, or by lowering the gain control. Find one position for average lighting and another for extremely bright conditions.
── ● ● ●

Pray for a Cloudy Day

Diffused sunlight from a cloudy-bright sky reduces contrast. This reduces burned out highlight areas and overly-dark shadow areas because the brightness range of scenes is reduced.

When shooting a cave or tunnel entrance from inside the dark interior during a sunny day, the bright entrance usually burns out. The remedy is to shoot such scenes on overcast days when the contrast between the bright entrance and the darker sides of the tunnel is reduced. The same principle applies to upward shots toward the sun. If you can't wait for optimum conditions, choose the camera angle that gives the least contrast between dark and light areas.

There is a drawback, however. Cloudy days restrict the amount of sunlight at deeper depths. If it's cloudy, try to stay above 60 feet to keep video images sharp and colorful.

Video Lights in Clear Water

A pair of 100-watt video lights is great for wide-angle shots in clear water. The brighter the sunlight, the greater the wattage needed. This is because sunlight can easily overpower the video light. Use a color-correction filter and set color balance as follows:

Distances up to three feet. Set white balance for indoor and use wide-angle diffusers to spread and soften the light.

Four feet and beyond. Set white balance for outdoor and

A video light adds color and detail to your sunlight shots.

remove one or both diffusers (secured with safety cords) so the lights reach out further.

● ● ● ─────────────────────────────────────
I use the outdoor setting if most of the lighting is by sunlight and the indoor setting if most of the lighting is by the video light. I use auto white balance when I can't decide between sunlight and indoor light balance.
───────────────────────────────────── ● ● ●

Too much video light, when used with the outdoor setting and the filter, makes images too red. At distances of about two feet or less, if you can't remove the filter, reset the white balance for indoor. If you can't do either, turn the light off. Some videographers place a blue gel over the video light when using the reddish filter and the outdoor setting. This prevents images from being too reddish when working close with an unfiltered video light.

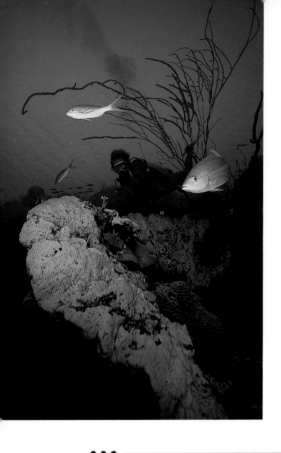

Use your video light to enhance colors and details in near subjects when shooting LS views.

●●● _____

Most beginning underwater videomakers start with one video light. However, a pair of 100-watt lights (for example) gives you more versatility than a single 200-watt light. Not only can you light both sides of a subject, but an assistant can aim a second light from positions you can't reach.

_____ ●●●

HOW MUCH WATTAGE IS NEEDED

How much wattage is necessary? For fill lighting in daylight, or artificial lighting at night, the following represents a general guide:

1 to 3 feet:	100 watts.
2 to 5 feet:	200 watts.
4 to 7 feet:	350 watts.
5 to 12 feet:	1,000 watts.

Increasing video light wattage doesn't solve all lighting problems. If you make a mistake with your video light it will

probably be because you used too much power. At medium distances, soft fill lighting is usually better than harsh lighting. Use high power only when you need it for long-distance lighting or to gain greater depth of field at close distances.

Don't let parts of the subject area get too close to the video light. Reflective fish or coral formations that are closer to the video light than your main subjects can easily burn out! Even lighting over the entire subject area, usually creates the best images.

Using Lights in Turbid Water

Because the video light will be the main light source, remove the color-correction filter and set the color balance for "indoor."

If the video light is mounted close to the camera housing, light will reflect back to the camcorder lens and cause the bright spots you see floating around in your picture. Use top or side lighting to minimize lighting the suspended particles in front of the lens. Removing any wide-angle diffuser from the light helps you direct light only where you want it.

Work as close to the subject as possible, and use as much sunlight as you can. The greater the amount of sunlight used, the lesser the bright reflectance from suspended particles. The basic procedures for using one or two video lights are:

Single video light. Hold the light a couple feet above the camera and aim it downward, slightly over the top of the subject. This angle gives two advantages: First, the light strikes the subject from the top (the angle we are accustomed to seeing sunlight strike subjects). Second, it minimizes the number of particles illuminated immediately in front of the lens.

Twin video lights. Don't aim twin video lights inward to intersect at the center of the subject. Aim them to intersect behind the subject's apparent position. The beams will overlap in the middle, and their patterns will cover the horizontal, wide-angle picture angle of the lens.

LIGHTING AT NIGHT

The video light is the primary light source for night videography (and/or for macro work). Set the color balance for indoor and remove the color-correction filter. A single 50-watt light is adequate up to about two or three feet; twin lights are good up to about four feet. For longer distances (and for the greater depth of field yielded by smaller lens apertures) use 100 watts or more.

If your housing has a color balance control, setting color balance manually produces the most accurate color balance. Take a piece of white plastic (or other white target) with you. Aim the camera at the white target, and adjust the color balance for "hold" if you have the appropriate controls.

Don't use your video light as a dive light during night dives. Prolonged use can overheat the bulb, and the battery will probably die before the dive is over. Carry a small dive light for cruising around. When shooting, don't aim a dive light at the subject. The dive light's beam will show up in the picture as a bright spot. If the person holding the dive light swings it about, the moving spot of light will be an annoying distraction in the scene.

For night close-ups, see the following chapter for more information about using video lights and focusing techniques.

Night video is often shot in the close-up mode. Be sure your subject is within the narrow zone of depth of field.

··· *12* ···

HOW TO SHOOT
VIDEO CLOSE-UPS

The tiny hermit crab finally peered out from his shell. I'd been waiting for several minutes, but wouldn't give up. His blue eyes stared at me, and his hairy little legs with their bright patches gripped his shell tightly. I framed him in the viewfinder and waited a moment for the autofocus to respond. Then, holding as still as possible, I began the shot.

SUNLIGHT CLOSE-UPS

You can use sunlight for both wide-angle close-ups with wide-angle lenses and dome ports, or macro close-ups with flat ports. For best results:

1. Use the color-correction filter (UR/PRO filter, or the filter provided by the housing manufacturer).
2. Set the white balance control for outdoor.
3. Set the shutter speed for 1/60 second.

USING A VIDEO LIGHT

Using a video light is your best option. A 50-watt light is sufficient for distances up to about two feet in dim light, but 100 watts is better in bright sunlight. For best results:

1. Remove the color correcting filter (used for sunlight).
2. Set the white balance for indoor.
3. Set the shutter speed for 1/60 second.

Two 50-watt video lights, with diffusers to soften the lighting, were used for this head-and-shoulders close-up.

If you experience consistent under- or over-exposure with auto exposure control, adjust the iris override (or gain control) for more or less exposure. If you have a high-power video light that provides more illumination that the automatic exposure control can handle at 1/60 second, increase shutter speed to 1/100 second or more. Trial and error experiments may be necessary.

Focusing Tips

Your eye must be able to focus on the electronic viewfinder screen if you use the image on the screen for manual focus. If your housing has an adjustable viewfinder magnifier, adjust it as follows:

1. Place the camcorder inside the housing.

Two 100-watt video lights, with diffusers, were used to shoot this clownfish. A sunlight shot would have lacked color and crisp details.

2. While wearing your facemask (especially important if you have corrective lenses), look at the viewfinder screen through the housing port.
3. Adjust the magnifier so you can clearly read the words and symbols shown on the screen. (The screen shows data when the camcorder is on standby.)

Auto focus. Give the automatic focus control a few seconds to find the correct focus before you start shooting. Shut the camera off between changes in camera angle or distance to avoid momentary blur as the system automatically refocuses. If you zoom during a shot, the automatic focus control must "see" the same subject area during the zoom.

Manual focus. Focus before starting a shot and avoid zooming while shooting. Because close–up depth of field is limited, manual focus can keep you busy with frequent adjustments.

Macro mode focus. With standard lenses in the macro mode, focus with the zoom control. Autofocus doesn't function, and the manual focus adjustment has little effect on image sharpness.

See chapters 4 and 5 for more about focusing.

HOLDING THE CAMERA STEADY

Holding the camera steady can be a major problem when shooting close-ups. Just a tiny amount of camera movement can cause recorded images to jump all over the TV screen when you view the tape. The smaller the picture area and the longer the camera-to-subject distance, the greater the importance of holding the camera steady. If you are poorly weighted or balanced, or are in a current or surge, handholding will be difficult.

● ● ●

Don't rest heavy housings on live corals. If you must brace the camera housing, do so in a way that doesn't harm marine life. A tripod is your best option.

● ● ●

Using a tripod. Most housings have a 1/4–20 threaded hole (a standard size) at the bottom for attaching a tripod. Buy a small, inexpensive tripod, or make a unipod to steady the camera for close-up videography. If necessary, tape small weights to the tripod legs (and possibly the housing) for ballast.

Work with the subject's movements. If movement is important to the scene, let the subject do the moving. For example, I shot a sequence of a clownfish moving about in the tentacles of an anemone. I began by watching the fish for a few minutes before framing him within the viewfinder. I chose a close-up distance that kept most of the fish within the picture area most of the time. Then, I shot a one-minute view of the clownfish moving about, but without moving the camera. Having the fish move about in a stationary picture area provided some excellent views for later editing.

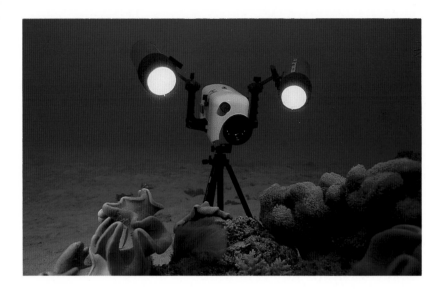

A tripod is an excellent tool for telephoto close-ups. You can start the camcorder and let it run as you search for new subjects.

Video close-ups are fun. They take your viewers to the heart of the action. They will enjoy seeing the hermit's blue eyes and his delicate legs. Only close-ups can show such fine detail. Only close-ups fill the TV screen with such private views of tiny creatures.

SELECTING BACKGROUNDS

To make a close-up subject appear bright and colorful, shoot it against a midwater background. A bluish, softly-focused coral background doesn't compete with your near subject, and the difference in sharpness, brightness and color accentuates the near subject. "Busy" backgrounds, or backgrounds that are too bright and colorful, can overpower your subject. When working with eels and other critters, be careful. Don't force them to vacate their lairs just for your shot.

● ● ● ──────────────────────────────────────

Video close-ups will enhance your video movies because you can fill the TV screen with sharp, colorful subjects. When shooting with CU lenses, it's best to group your shoots. That is, plan your long shots for one dive and your close-ups for another. Otherwise, you won't do well with either.

── ● ● ●

TELEPHOTO WITH SUPPLEMENTARY CU LENSES

I placed this topic last because it is a specialized application. Although the trend is toward full-range autofocus lenses, you can use supplementary CU (close-up) lenses with standard camcorder lenses to shoot telephoto close-ups. Picture areas can be two inches or less in width.

When you zoom to the telephoto setting, you lose close-up focus. This is because–even with an automatic macro lens–the

Flat housing ports are best for close-ups. Supplementary CU lenses can be used with some camcorder lens, but full-range autofocus lenses are easier to use.

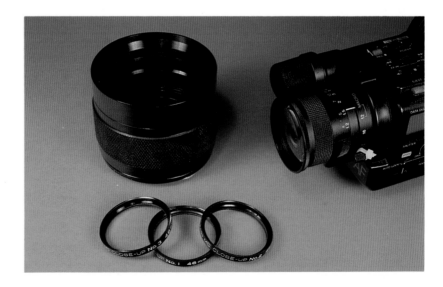

minimum focus is about 3.5 feet. Thus, you must screw a supple-
mentary close-up lens into the accessory threads of the
camcorder lens.

The three common sizes (in diopters) are the No. 1, No. 2
and No. 3 CU lenses. The higher the number (diopter), the stron-
ger the close-up lens.

With a camcorder lens focused for four feet, the approxi-
mate focused distance ranges, from the wide-angle to the
telephoto settings of the camcorder lens, are shown below:

No. 1 CU lens	20 to 40 inches
No. 2 CU lens	14 to 20 inches
No. 3 CU lens	10 to 13 inches

The picture areas will be less than two inches in width in
the telephoto mode. Thus, it is extremely important that the
camera be held steady. Use a tripod.

··· *13* ···

TOPSIDE
VIDEO TECHNIQUES

Although this is a book about underwater video, you will
shoot some topside shots as you produce your underwater
video movies. This chapter will give you some basic guide-
lines.

HUMIDITY AND CONDENSATION

You have prepared your camcorder carefully: the battery
is fully charged, the tape is in place, and you've tested
the system. Everything is O.K., so you leave your cool, air-
conditioned room. No sooner do you enter the warm, humid
outside air than you detect the first sign of trouble. The lens
fogs over and the outer surfaces of the camcorder become moist
and slippery. Moving from cool, dry air to warm, humid air
has caused condensation. You clean the lens, wipe off the
camcorder, aim the camcorder at your subject and trigger the
shutter. But nothing happens! The built-in dew circuit detected
moisture and shut off the electronics.

The best way to combat condensation is to prevent it from
happening. Use a hair dryer to warm the camcorder–the lens,
exterior and inside the tape compartment–with warm (not hot)
air before going outside. Condensation won't form if the
camcorder is at ambient air temperature.

Outside, in direct sunlight, your problems aren't over. Sunlight
can overheat the camcorder and could affect its taping capa-
bility. Thus, when not actually in use, keep the camcorder out
of direct sunlight. Store it in a light-colored camera case or
wrap it in a white cloth.

ABOARD A BOAT

In my opinion, a small dive boat is a dangerous place for topside videography because of spray, wet hands and dripping hair. Thus, I recommend the following precautions:

- Resist the temptation to remove the camcorder from its housing if there is danger of spray striking the camcorder. Yes, image quality will suffer when you shoot through a dome port in air, but would you rather have a degraded image or a ruined camcorder?
- If you remove the camcorder from its housing while on a boat, rinse the housing with fresh water and dry it thoroughly before opening it. Then, rinse and dry your hands, face and hair. It only takes one drop of seawater in the wrong place to ruin your camcorder!
- When not in use, keep an unhoused camcorder wrapped in a splash-proof camera bag or towel to protect it from sun and spray. During use, you can wrap it with a transparent cling wrap (don't cover the lens). You can still operate most controls and the wrap will ward off water droplets. For extended topside use, consider a flexible Ewa Marine Housing to make your camcorder splashproof.

BRIGHT SUNLIGHT

Mornings and afternoons are usually the best times of day for topside shots in bright sunlight. Direct, overhead sunlight creates hard lighting that accentuates dark shadows in eye sockets and beneath chins and causes your subjects to squint. Skin blemishes and wrinkles are accentuated, and faces appear haggard. Low-angle sun, usually at angles less than 45 degrees, reduces many harsh shadows.

When shooting in bright sunlight, the brightness range (contrast) between sunlit and shaded areas can cause problems.

Overhead sun causes harsh shadow areas. For best results, use a small video light for fill lighting or shoot in open shade.

Automatic exposure control can underexpose bright scenes. If you have manual override, watch the image in the electronic viewfinder as you adjust exposure.

Why? The camcorder can't record a brightness range as wide as your eye can see. The camcorder may be able to handle either the dark areas or the light areas, but not both. For example, if your subject is sitting in the shade, but with her face in the sun, the camcorder will have trouble recording both the bright face and darker torso. The automatic exposure control will probably expose for the darker torso, and overexpose the face. If your subjects are sitting in the shade, and the automatic exposure control senses a bright background, it will underexpose the shaded subjects.

Some solutions to the above problems are:

- Place your subject either totally in the sun or totally in the shade.
- Use the manual iris override to increase exposure when subjects are backlit or against a bright background.
- Use a reflector to bounce some fill light into the shadow side of the subject.

I prefer to shoot with the entire picture area in the shade. This eliminates harsh shadows and produces a more pleasing video image.

Cloudy Days

Contrary to what many beginning videographers believe, you can usually shoot better video on cloudy days. Light cloud cover scatters the sun's rays and provides diffused lighting that reduces the brightness range of light and dark subject areas. Thus, your camcorder can record both light and dark areas more realistically.

Most people look better when illuminated with soft, diffused light. They don't squint at the camera, and they don't have harsh shadows in their eye sockets and under their chins. Eliminating harsh shadows in backgrounds also helps produce better images in the entire picture area.

STEADYING THE CAMCORDER

The best way to steady a camcorder is to use a tripod. The second best way is to rest it on a solid object, such as a railing. If handholding the camcorder, brace yourself by leaning against a wall, or by bracing your elbows on a table or railing. When standing, try the "Tai Chi" stance: stand with your knees bent, feet about 18 inches apart and your toes pointed slightly inward. To pan, turn from the waist. To tilt, bend your torso forward or backward.

SHOOTING TIPS

The following tips will make your topside videomaking easier to shoot and will lead to better video movies:

- For the sharpest images, focus with the lens set for telephoto (the highest number on the zoom control scale). The lens will now be at optimum focus at any setting, from telephoto to wide-angle.
- To reduce depth of field (to blur out cluttered backgrounds), set for high-numbered shutter speeds. To increase depth of field (to include both foreground and background), set for low-numbered shutter speeds.
- Remember to set the white balance. Use the outdoor setting for sunlight, the indoor setting for artificial light, and the automatic white balance for mixed lighting. Older video cameras and camcorders may require manual light balancing. You aim the camera at a white target and press the white balance switch. If your camera requires manual white balancing, carry a white card in your camera bag to use as a target.
- Start the topside sequences with a wide-angle establishing shot to show location, weather and time. Shooting divers boarding a boat, for example, gives viewers a feeling for the overall scene, the weather and the time of the action relative to the total video story.

- Use lots of medium-distance shots when showing people. Don't cut people off at natural joints (elbows, knees, etc.) when you frame them in medium shots. Cutting between joints such as elbows and shoulders appears more natural.

- Give your subjects headroom, looking space and walking space. Put some space between the top of the subject's head and the top of the picture. If the subject is looking at something out of the picture, put more space in front of the subject's face than behind the head. If the subject is walking, put more space in front of the subject than behind.

- Don't pan (move the camera sideways) unless panning is necessary for the shot. If you pan, move the camcorder slowly. Once you start panning, don't reverse the pan.

- Only zoom for special shots; otherwise, the zoom will lose its effect. In most cases, it's best to stop the camera, change image size and camera angle, and then start shooting again.

- You can fade in (scene starts dark and fades into a picture) even if your camcorder doesn't have a fade control. To fade in, set the iris control for "close." Start shooting, then slowly rotate the iris control to "open." This may take practice, but you can do it.

- If you plan to edit later, start shooting each scene early and stop shooting late. This gives you some "head and tail" space for editing. If scenes are important, shoot them more than once; you can select and edit out the best scenes later.

- Go for the action! Don't shoot long, boring scenes just to fill tape; if it's boring to shoot, it will be ten times as boring to watch.

- Keep scenes short—about three to seven seconds. Three five-second scenes, shot end-to-end are more interesting to view than one long 15-second scene.

- Each time you shoot a new scene, however long or short, change camera angle, image size or both.

··· *14* ···

HOW TO PUT
MODELS AT EASE

The reef is beautiful, so you decide to do a slow pan to a
diver. Your dive buddy—intimidated by your video camera—is
being careful to stay behind you.
* You start the pan, turning slowly, then stopping as your*
buddy enters the scene. He suddenly realizes that he is on
camera. His body stiffens, and he frantically swims out of
camera range. The shot is ruined.

PEOPLE ARE CAMERA SHY

Divers are often camera shy and react in unnatural ways
when you aim your video camera at them. Some avoid
you like the plague; some get nervous and act silly; some overact
and move stiffly or use exaggerated gestures. Even if they agreed
ahead of time to pose, they often turn away and give you a
view of their tank and fins when you start shooting.

RELAXING MODELS

Avoid putting models under mental pressure. Detailed shoot-
ing plans and signals will confuse most divers and cause them
to freeze up mentally. They are afraid of making mistakes or
appearing silly when the tape is viewed. Thus, your first goal
is to get your models relaxed. Your epic plans can follow. There
isn't a secret potion to relax models, but you can do the fol-
lowing:

Make haste slowly. Whenever possible, give models a

chance to explore the location or dive site before you start shooting. Suppose you want to start your video with an establishing shot of your spouse in front of the dive resort sign. Don't rush. Let your model unpack and freshen up before posing. When documenting a dive vacation, use the first day to look for the best views and camera angles.

Don't be bossy. Some videographers get a case of inflated ego when they start rolling tape. Topside, they shout orders at the poor souls in front of the camera. Underwater, their gestures are abrupt and rude. Their words and actions only make their models wish they (or you) were somewhere else. Be friendly. Relax and show that you are having a good time. This helps your models relax and have a good time with you.

Get them accustomed to the camera. Just the sight of a video camera spooks some people. If so, your first job is to condition them to the camera's presence. Before shooting, place the camera in an obvious place. Ignore the camera and hope

Divers frequently are afraid of your video camera.

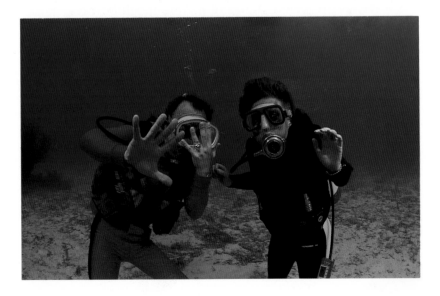

that its presence will soon be taken for granted. When you start shooting, don't aim the camera directly at shy people. Shoot them last, after they've seen your first subjects survive.

Let them try it. If someone shows interest in the video camera, let them hold it. If possible, let them shoot a couple of short shots. Remember, your goal is to reduce their fear of the camera.

Use dry runs. Use practice runs to rehearse important actions, topside or underwater. Concentrate on framing your shots and let your models learn their roles. They will relax and appear more natural by the second or third run. However, be sneaky and shoot the rehearsals! Your best takes may occur when the models think it's for practice.

Don't get too close. Use your zoom to increase camera-to-subject distance for topside shots, especially for close-ups of faces, whenever recording sound isn't important. Shoving your video camera into people's faces can unnerve them. Underwater, avoid close-up cut-in shots to faces unless you are certain the models won't panic.

Be discreet. Avoid shooting people in unflattering poses. People fear being embarrassed, and if they even suspect possible embarrassment, they won't cooperate. Men are sensitive about bald spots, and people with heavy hips fear fanny shots. Promise that you will avoid shooting unflattering poses, and will delete any inadvertently captured poses when you edit the tape.

Focus on action. Talk about the action, rather than the model. Tell the model what action you want them to do; don't just point the camera at a person and expect them to invent something on the spot. If fish feeding is the local sport, talk about this. If your model is a photographer, shoot him as he takes a picture.

KISS—keep it super simple. While you may have a de-

tailed shooting plan, give it to your models one step at a time. If you overload them with complicated instructions they will forget their instructions and find excuses not to pose.

Use an underwater slate. Summarize your plans on a slate that you can use to remind models what they should do. Leave some blank space for writing notes.

LOOKING AT THE CAMERA

Some models consistently look at the camera while you are shooting. Others will look, realize that they've made a mistake, and will quickly look away. In either case, an unplanned glance at the camera can spoil the mood of your shot. If your model sneaks frequent peeks at your video camera, maybe you can use this as an asset. It works as follows:

Buddy with the camera. Tell your models to pretend that

Tell divers to act as if the camera lens were a dive buddy. They can point out objects for the camera to see.

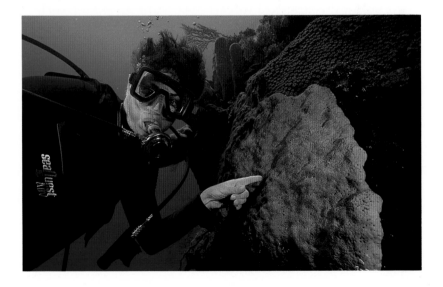

your video camera is their dive buddy. Tell them to look at the camera any time they would look at their dive buddy.

Make gestures to the camera. In addition to looking at the camera, tell them to make gestures to it. Signal it to "follow me," "look over there" or "I'm low on air."

● ● ● ────────────────────────────

Making gestures to the camera may sound crazy, but it works. When the viewer—any viewer—watches the tape, it seems that he (the viewer) is part of the dive. You only need to ask your model not to point at objects that are far away, and to make sure that you are taping him when he makes the gestures.

──────────────────────── ● ● ●

TIPS FOR MODELS

- Tidy up your dive gear. Avoid dangling straps and consoles.
- Swim slowly with your hands at your sides. If your arms are outstretched, your hands may be out of the picture.
- Use a slow, gentle kick. Avoid the frog kick.
- Look at the strongest subject area that is near you, such as a large sponge or fish.
- If you want to see what the videographer is doing, turn your head past him without stopping the motion. If you happen to look at the camera lens, pretend that the camera is another diver.
- If you are videotaped with someone else, don't block the camera's view of the other diver.

VIEWING YOUR TAPES

Let your models see themselves on a TV screen as soon as possible. Even those who protested the most will want to see themselves in action. They usually want to see the tape more

than once. The first time, they may only see their mistakes. But by the second time, they will probably relax and enjoy the show. If they want to see the tape a third time, they're hooked and will pose better next time.

Make as many positive comments as possible. Praise your model's good actions (especially those of your spouse) if you want them to pose again. Their mistakes will be apparent and don't need your elaboration. Tell them what you want next time rather than criticize what they are watching on the screen. The best ideas for improving your video movies will often come from the models. Bring them into your planning and your model handling skills will multiply.

··· 15 ···

THE 14–STEP
FORMULA FOR
SHOOTING A DIVE TRIP

Your dive club is planning a one-day boat dive. For you, this is the golden opportunity to test your video skills. This isn't a casual "point and shoot" situation. You want a structured, edited story that you'll be proud of.

WHAT IS THE 14–STEP FORMULA

The 14-step formula is a list of suggested shots that you can modify to your specific situation. It requires minimal posing or special efforts on the part of your group. Most of your people shots will be natural—you will shoot them as they are. The basic shots are listed below:

1. Group establishing shot.
2. Boarding the boat.
3. Preparing for the dive.
4. Entering the water.
5. Underwater establishing shots.
6. The underwater action.
7. Divers ascending.
8. The safety stop.
9. Individual head and shoulder shots.
10. To the ladder (underwater).
11. Up the ladder (lift).
12. Up the ladder (topside view).
13. Activities aboard the boat.
14. Group leaving the boat.

Some of these steps will require one shot; others will re-
quire several shots. You can, of course, modify the steps by
substituting a beach for the boat if shore diving. If you are at
a resort modify the steps for the resort.

The following sections show the steps for shooting a one-
day or half-day boat trip. As you read, think of how you can
modify the 14 steps to fit your specific situation.

Establishing Topside

Your first goal is to establish the location and event, and to
introduce the cast of characters to the viewer. In the follow-
ing examples, we will assume that you are shooting a half-day
trip on a dive boat. It works as follows:

1. Group establishing shot. The immediate goal is to set
the stage for the boat dive. Start with two or three LS views
of the group on the dock as they prepare to board the boat.

If possible, have the group gather and face the camera. Then,
have them turn and walk toward the boat as you continue
shooting. You don't have to shoot each individual; those you
miss can be shot later. These topside introductory shots can
be short: 15 or 20 seconds is about the maximum. Shoot more,
however, and edit later.

2. Boarding the boat. Use your zoom control, or move in
closer, for shots of divers boarding the boat. You can start
shooting on the dock, then move to the boat to add an over-
lap to this series of shots. Arrange ahead of time to have your
gear taken aboard so you can concentrate on shooting divers
boarding the boat.

3. Preparing for the dive. Shoot several shots of indi-
vidual divers gearing up. Concentrate on those persons whom
you missed in steps 1 and 2. If the divemaster gives a chalk
talk about the site, get some of this on tape. Begin with ten
seconds of the dive master giving the dive briefing. Then, cut
to a shot of the group watching the dive master. End with
another shot of the divemaster.

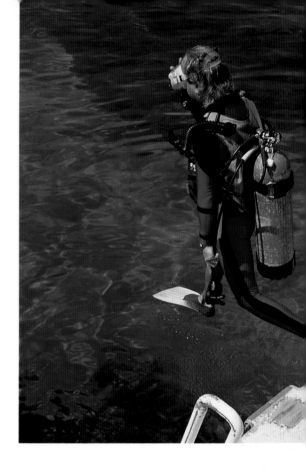

Shoot several shots of divers entering the water.

4. Entering the water. If divers take turns entering the water, shoot each person as they approach the entry point and step into the water. Ask each diver to look at the camera, smile and wave just before stepping off.

Shoot about 10 seconds of each person approaching the entry point. Stop the camera until they get their gear adjusted to avoid long scenes showing nothing important. Ask them if they are ready. If they say yes, ask them to look at you. Start the camera and pan with them as they step into the water.

● ● ●

The purpose of these "mug shots" is to make sure that you have a head-and-shoulders shot of each person. If you miss someone, make a mental note to get them later.

● ● ●

Establishing Underwater

If the group consists of novice divers or macho explorers, don't even try to plan complicated scenes or actions. Settle for an establishing shot to start the underwater action. Shoot whatever action you see. Then shoot a resolving shot to end the sequence. Let's continue with the steps:

5. Underwater establishing shot. Get below the boat and shoot some long shots of divers descending. Ask some (ahead of time) to swim over you so you can shoot an overhead reverse shot. Don't try to include everyone. Some will be clearing their ears on the line; others will be heading in the opposite direction. Concentrate on small groups and buddy pairs.

Shoot divers coming down the descent line. Get low, and use sea fans or corals to frame your subjects. If there is a bright overhead sun, position yourself in the shadow of the boat. This reduces image burnout, and you may get some dramatic sunbeams radiating around the boat.

● ● ● ───────────────────────────────

If you get into the water last, because you were shooting the entry shots, shoot the underwater establishing shots on the second dive and edit later.

───────────────────────────────── ● ● ●

6. The underwater action. Your control over the situation ends quickly when the group reaches bottom. (People who promised to pose frequently develop subsea amnesia.) Shoot several shots each of as many persons as possible. Remember that several five-second shots, taken at different camera angles, will be more fun to view than a single 15- to 30-second shot.

If several divers are swimming along a wall, try to get ahead and below them. Shoot their approach and pan slowly with them as they pass by. If you lag behind the group, their fins and tank bottoms are all you'll see.

If fish feeding is a feature of the dive, shoot some long-

shots of the group. Then, move in for medium shots of individuals feeding fish. Be sure to shoot some fish close-ups for cut-in shots, and some diver's faces for cut-aways.

TRANSITION TO TOPSIDE

You can usually anticipate the action better as the dive ends. It's time to finish your "mug shots" and resolve the underwater action. To continue the steps:

7. Divers ascending. Try for a reverse of your opening underwater establishing shots. Get low and frame divers with seafans, corals, wreckage or anemones as they head up the ascent line. Then, move in for some midwater shots at different angles.

8. The safety stop. A few shots of the group decompressing on a line or hangbar help make the transition from underwater action to the mug shots that follow.

Make sure to shoot ending shots to resolve the underwater portion of your video. Photo: Mike Mesgleski.

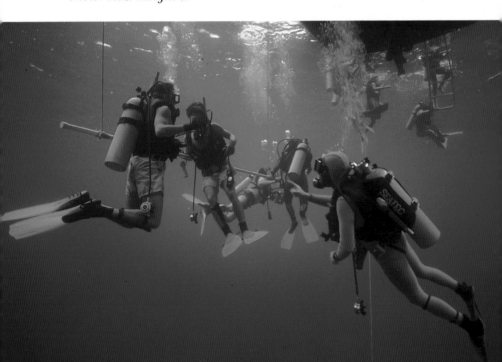

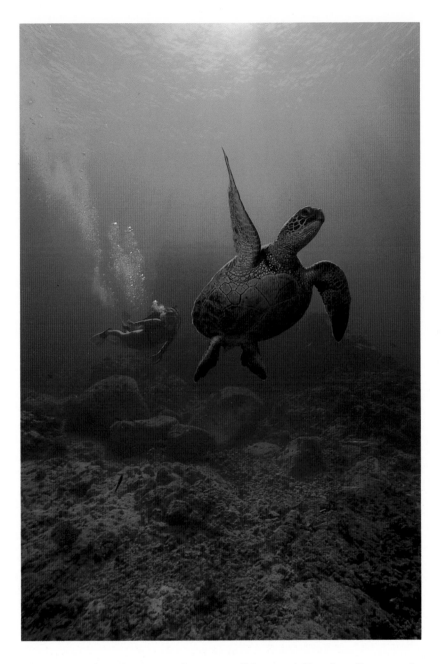

Shoot as much underwater action as possible, especially when divers can be shown with marine life.

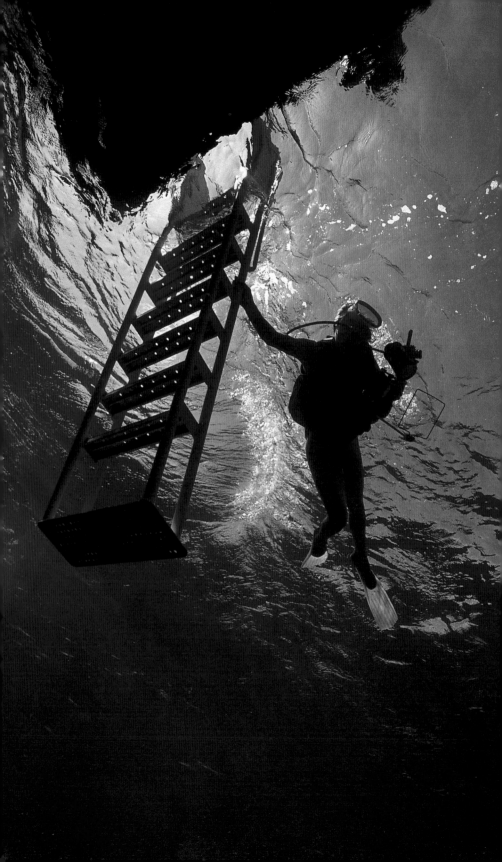

9. Individual head and shoulder shots. Now is your golden opportunity to get mug shots of those persons you missed up to now. It's O.K. if they clown around or make faces at the camera; they'll enjoy their antics when they view the finished video.

●●● —————————————————————————————

When shooting mug shots, position yourself so the sun is behind your back and you are slightly above your subject. This helps il-luminate their faces. If you have a filter on the camera, remove it. If you can't, reset white balance for indoor if you have a white balance control.

————————————————————————————— ●●●

10. To the ladder (underwater). Shoot a transition shot showing one diver leaving the safety stop and swimming up to the ladder. Because divers often spend a minute or more removing fins, etc., end the scene (by stopping the camera or editing later) as soon as the diver grasps the ladder.

11. Up the ladder (lift). This is a special "lift the camera" overlap shot. As soon as the diver starts up the ladder, ex-hale and rise. Lift the camera up through the surface for a topside shot of the diver ascending the ladder.

●●● —————————————————————————————

You can minimize water droplets on the lens port while shooting lift shots, or other shots where the lens port is only partially sub-merged. Try coating the outer surface of the port with Rain-X, The Invisible Windshield Wiper. Rain-X is available at automotive parts stores.

Shots 10 and 11 end the transition between the dive and the topside action that follows. You only need one "diver up the lad-der" shot. However, shoot at least two so you can choose the best one when you edit.

————————————————————————————— ●●●

A diver reaching for the ladder is a good ending LS for the underwater portion of your video.

TOPSIDE RESOLVING SHOTS

12. Up the ladder (topside view). Get out of the water and shoot an overlap of a diver coming up the ladder. If you previously missed shooting any divers entering the water, you can add them with additional "up the ladder shots."

13. Activities aboard the boat. Because there will be a mix of excitement and confusion as divers return, shoot several shots of divers removing gear and talking about the dive. If possible, end by gathering as many of the group as possible and shooting a slow pan. If your subjects are shaded under a canopy, use the iris override to open the aperture. Otherwise, the automatic exposure control will respond to the bright background and underexpose your near subjects.

14. Group leaving the boat. Get off the boat quickly and take a few shots of divers disembarking. If possible, have the group assemble by the boat, face the camera and then walk past you as you shoot this ending scene.

● ● ●

The topside shots—especially aboard the boat—can be hazardous to your equipment. Avoid the temptation to remove your camcorder from the housing unless conditions are ideal. The optics and sound won't be as good if you shoot through the housing port, but salt spray won't ruin your camcorder and condensation won't trigger the dew shutoff mechanism that turns the camera off.

● ● ●

PART
... *4* ...

PLANNING AND EDITING YOUR VIDEO MOVIE

$\cdots 16 \cdots$

THE JOYS
OF PLANNING
AND DIRECTING

The previous chapter was based on a one-day dive trip. This chapter takes you a step farther. You're now going to an exotic dive location for several days. You want to shoot a video diary of the trip in story form. Several of your friends want to help, and everyone expects to see themselves on the finished tape. You are now the planner, director, cameraperson and editor of a video production.

YOU NEED A STORY LINE

The purpose of the story line is to lead your viewers from scene to scene, in a logical sequence. The story doesn't need to be complex. You can simply show events, punctuated with cut-ins and cut-aways, as they happen.

If only a few people are involved and you control the diving, your video movie can be easy to shoot and edit. However, if several divers are involved, and if you can't control the diving, your video epic will require careful planning and directing.

WHO DOES WHAT

Determine who will give you the most help and cooperation, and involve them in your overall planning. Specifically, you need to decide on the following:

- Who will help you formulate the basic story line?
- Who will direct and position actors, topside and underwater?
- Who will be in charge of any special props?
- Who will be your assistant camerapersons?

Any group of divers shooting a video movie can have disagreements, and tempers can flare if you don't define roles and responsibilities ahead of time. Plans can be changed, and it's easier to change a plan than to stumble along without one.

The entire group can participate in basic decisions, but you need to exert leadership. You need an organized approach if you want a structured video story. Specific responsibilities and roles may shift from one person to another as the shoot progresses, so make this clear ahead of time.

● ● ● ─────────────────────────────

- ***Plan.*** *Decide on the purpose and scope of the video production.*
- ***Organize.*** *Determine what needs to be done, if you have the hardware to do it, and what special props are needed.*
- ***Delegate.*** *Define specific duties and give specific assignments to your assistants.*
- ***Supervise.*** *Keep track of what your assistants are doing, without nagging. Give them the help they need.*
- ***Find something to praise.*** *Use the carrot rather than the stick. It gets better results.*

───────────────────────────── ● ● ●

STUDY THE DIVE SCHEDULE

If possible, learn the daily dive schedule ahead of time. If your boat captain drops you on a new site for each dive, a smooth-flowing story will be hard to shoot. If your story line is complex, simplify the story. It's better to KISS (keep it super simple).

To maximize control, you and your group should charter the boat and discuss the dive schedule with the captain ahead of time. If dive schedules are predictable, list the following as soon as possible:

Listen carefully to dive briefings to determine the most photographic features of the sites.

- Where will you be diving each day?
- What are the most photographic features of each site?
- What are the depths and diving conditions?
- Can you repeat sites if you need to reshoot?

USE INDEX CARDS TO STORYBOARD

Once you have a general plan, make a list of the basic shots you intend to take. Make stick–figure sketches on 5 x 7 inch cards. While professionals may use a storyboard, the cards are a more flexible way to plan. You can add or delete cards, or change their order anytime.

● ● ●

A storyboard is a series of sketches—much like a cartoon strip—that shows your story with pictures. This is how professionals often plan their productions. If you make a storyboard, use a loose-leaf binder so you can make changes easily.

● ● ●

Write necessary information such as the designations LS, MS or CU, establishing shot, transition shot, resolving shot, cut-away or cut-in on the front of the card. Write the narration on the back.

The complexity of the cards (or storyboard) depends on the complexity of your video movie. You may opt to use only a shot list and make only those sketches needed to explain your ideas to others.

MAKING A SHOT LIST

Anytime you plan to shoot more than two or three scenes or views of a scene, make a list of the shots. Use a laundry marker to write the shot list on plastic tape attached to the camera housing. If you don't have tape, use a pencil and dive slate.

Here is a sample shot list:

LS: Diver by large coral head.
MS: Diver looking at soft coral.
CU: Diver's view of soft coral.
CU: Cut-away to diver's face.
MS: Diver looks up from soft coral.
LS: Diver swims out of view.

To tell another diver what shot you wish to take, simply point to the list. If your model has a copy of the shot list on a dive slate, simply hold up one or more fingers to indicate the shot number.

HANDLING NON–PARTICIPANTS

If everyone is participating or interested, shooting the video story will be easier. However, you may be saddled with non-participants. They have a tendency to swim in front of your camera, momentarily stare at the lens and then swim frantically away.

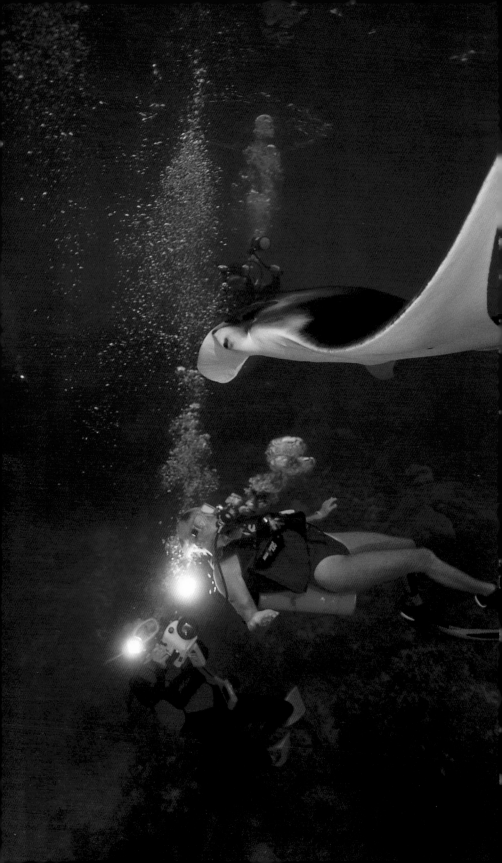

Tell non-participating divers to relax if they accidentally get in front of the camera. If they look at your camera lens, they should act as if they were looking at another diver. Then, they should simply continue their dive. If you have a specific scene or action planned, let everyone know about it. Try to shoot special scenes when only the desired models are present. If everyone wants to dive on the same part of the site, try to agree on a "take turns" schedule.

REHEARSE IF YOU CAN

You can rehearse some underwater shots before entering the water. If, for example, you wish to show an underwater photographer photographing a model, work out the distances and angles topside. First, they must be closer together than they normally would (so you can get them both in frame at close distance). Second, they should angle themselves so you can view one or both faces. Third, the photographer must raise the camera, flash the strobe and lower the camera within about five to seven seconds. Otherwise, the action will be too long. The still photographer is a model whose goal is to perform for your video. He may have to sacrifice a frame of film while posing.

If you need a model aligned with an underwater object, try letting the model look through the camera viewfinder. Then, you can position yourself where you want the model to be. This gives the model an idea of what you want.

For complicated scenes that can be repeated–such as over-lapped action–shoot a practice run. See what distances and camera angles are best for the shot. If your models are nervous, tell them that you will shoot a dry run without the camera running, but shoot anyway. Your first shot is often the best, so fib a bit.

Non-participants can block your camera's view of your subject. If strong action is happening, keep shooting! You never know what will happen.

REPEAT IMPORTANT SHOTS

If a shot is extremely important, shoot it two or more times. This is especially true for beginnings (which set the mood and introduce story segments) and endings (which resolve story segments).

WATCH YOUR CONTINUITY

If you show a LS of a diver with a full wet suit, followed by an MS of the same diver wearing a shorty suit, you've lost continuity. Whatever gear a diver wears or carries in a series of shots which will be joined to show a continuous action should remain the same. If several persons are involved in your production, assign someone the job of continuity editor.

Screen direction also has continuity. For details, go back to Chapter 10. Directional continuity usually can't be assigned. You must handle this yourself!

SHOOT THE INCIDENTALS

Shoot several shots of your principal actors' faces, as they look in different directions. Also, take some shots of bubbles rising, that seagull resting on a piling, or that fish peeking out of its lair. These incidental shots will be worth their weight in gold when you need cut-in and cut-away shots while editing. The more you have to choose from, the more creative your video movie can be.

SHOOTING TO EDIT

If you plan to edit later, shoot to edit. Give each shot some "head." Start the camera running several seconds before the desired action begins. Also, give each shot some "tail." Keep the camera running for several seconds after the action ends. The head and tail provide space on the videotape for editing. Note: Some editing systems require several seconds between

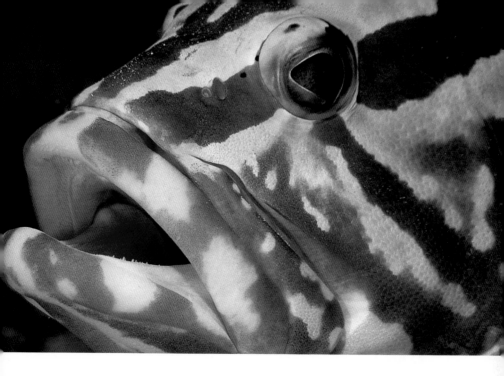

Creature close-ups, such as this grouper's inquisitive stare, provide valuable footage for cut-aways.

cut-in and cut-out points. If you edit tightly in camera, you will have difficulties if you try to edit later.

EIGHT IMPORTANT STEPS

1. Start with a basic story plan that is within your shooting and equipment capabilities. When in doubt, KISS—keep it super simple.
2. Define responsibilities early if the production is a group effort.
3. Learn the dive schedule. List the depths and features of each site.
4. Take a shot list underwater anytime you are shooting to a plan.
5. Shoot important scenes at least twice.
6. Maintain continuity.
7. Shoot as many incidental shots as you can.
8. Give each shot several seconds of head and tail.

··· *17* ···

INTRODUCTION TO EDITING

Don't bore your viewers with hours of tape. Ten to fifteen minutes of jam-packed action is all they want to see.

EDITING IN CAMERA

What you see in the viewfinder while shooting is what your viewers will see on the TV screen during play-back. Editing in camera is quick and dirty; what you shoot is what you get!

However, editing in camera causes three problems:

- You must shoot each shot in correct sequence.
- If you miss a shot, you can't squeeze it between existing shots on your tape. You can only shoot over existing scenes (insert editing).
- Videotapes edited in camera are difficult to edit later. Accurate cuts in (starting edited scenes) and cuts out (ending edited scenes) will be difficult because you usually don't have enough "cutting space" between scenes that show the desired action.

SHOOTING FOR EDITING

Shooting for editing (postproduction) is different than edit-ing in camera. You can shoot scenes in any order, and assemble them in any desired sequence later. Shooting scenes in order, however, will speed the editing process.

Start the camera at least 10 seconds before the action starts,

and let it run at least 10 seconds after the action ends. This puts space between scenes for editing. To avoid rewinds of the original tape, some editing controllers need a minimum of 10 seconds of tape between each edit stop and start point.

DELETE EDITING

Delete editing doesn't require special editing equipment. You merely delete unwanted scenes while dubbing (copying) the original tape from camcorder to VCR.

View the tape first to see where you want to start and end scenes. Use the counter numbers as a guide and watch the screen carefully. The recording VCR must be in record standby (press the pause button) whenever you fast forward or reverse the playback camcorder tape to search for scenes.

Cuing (setting the camcorder and VCR for start and stop points for scenes) takes practice. There are slight delays in the start and stop times of different camcorders and VCRs.

ASSEMBLY EDITING

Basically the same as delete editing, assembly editing means rearranging scenes in a different order. If you edit manually (without an editing controller), you must locate each selected scene on the master tape. Then, as with delete editing, cue both the playback camcorder and the recording VCR, and press their pause buttons simultaneously.

SYNCHRONIZED EDITING

Some higher-priced VCRs have special features for editing, such as synchronized editing. The playback and recording VCRs are connected with remote cord in addition to the video and audio cables. When the synchronized edit switch of the playback

VCR is pressed, the pause modes of both VCRs are activated. You push one button on one VCR, rather than simultaneously pushing the pause buttons of two VCRs. Some newer VCRs may be able to remember cue points for a limited number of scenes.

IMPROVING YOUR DUBS

Any time you dub (copy) a tape, some picture quality is lost. The following points present methods of minimizing loss of quality:

- Use SP (standard play) rather than longer-play tape speeds.
- Use shorter, thicker cables especially designed for video dubbing. Longer, thinner cables designed for audio dubbing will work, but with greater picture quality loss.
- Look for an "edit switch" on your camcorder and VCR. It may be in the camcorder battery compartment, or it may be selected from a menu displayed in the electronic viewfinder. With VCR's, look on the control panel. The edit switch bypasses some circuitry for viewing, so the video signal is recorded in its purest form. The edit switch isn't required, but using one reduces loss of picture quality.
- Inexpensive signal boosters may help if your camcorder and/or VCR doesn't have an edit switch. The booster attaches between the camcorder and VCR. Improvement is most noticeable in shadow areas.
- Clean video recording heads after every 20 to 30 hours of use. Special head cleaning cassettes are available. Caution: Check the camcorder and VCR owner manuals for cleaning recommendations. Improper cleaning could damage video heads.
- Record on a VCR that has flying erase heads. Otherwise, you will see glitches (streaks of color) at the edit points on the duplicate tape.

• When dubbing from a Hi8 or S–VHS camcorder to a S–VHS VCR, use the S–video inputs, outputs and connecting cable. Transfer in S–video even if you are making a standard VHS copy. This may result in slightly better image quality.

EDITING CONTROLLERS

An editing controller connects (with cables) between a playback VCR (often the camcorder) and a recording VCR. A cable from the recording VCR (or editing controller) attaches to your TV set so you can watch the screen while editing. As you play and view the original tape, you press buttons on the editing controller to mark the start and stop points of the desired scenes. The editing controller "memorizes" each start and stop point.

A typical editing system: camcorder, Videonics Editing controller below camcorder, Videonics Video Processor and S-VHS VCR. The future trend will be computer editing.

Once most editing controllers are programmed with your edit points, you can make as many second-generation copies as you wish from the original tape. You can reprogram the editing controller to add or delete scenes, graphics and titles to produce different versions of the final tape.

Some editing controllers have built-in titling and graphic functions, fades, wipes and other special effects. These features may require several passes to complete. With the Videonics DirectED PLUS edit controller, for example, several rewinds are needed to insert and/or rearrange scenes, insert graphics and copy the final production.

For complicated editing, an editing controller is easier to use than a VCR's built-in editing functions. Editing controllers usually have easy-to-operate push buttons. VCR controls are often small and awkward to operate. Edit controllers start and stop scenes more accurately than you can with a VCR pause button, and it's easier to make changes in start and stop points.

The Videonics Video Processor shown here is one of the many accessories available for color correction, audio mixing and other editing functions.

Video Processors (Equalizers)

Video processors can adjust color, brightness, contrast and often have an enhancement adjustment for picture sharpness. Processors are connected, with dubbing cables, between the playback VCR (or camcorder) and the editing controller. Preview the tape and log exactly what processor settings are best for specific scenes. Use tape to mark switch and slider bar positions. When a scene is being played or edited, you must be able to make accurate adjustments instantly!

If your original tape has good color, brightness and sharpness, a video processor is of marginal value, except for special effects. It can correct many color and brightness problems, but can't transform a blurry original into a crisp copy.

Video and Audio Mixers

Video mixers allow you to switch from one video source to another, with fades and dissolves between scenes. Audio mixers are used to mix sound sources, such as narration and music. Audio mixers are often built into video processors. Mixers designed for video editing usually contain circuits for both video and audio mixing.

Character Generators

A character generator electronically produces letters and numbers for titles. It can be a stand-alone accessory, or may be a built-in feature of an editing controller or video processor. Many camcorders have a simple, built-in character generator (titling option).

··· 18 ···

ADDING SLIDES
AND GRAPHICS

*The purpose of this chapter is to show you how to add im-
ages from color slides, artwork and movie footage, to your
underwater video movies. Each of the techniques discussed
assumes a minimum investment in specialized equipment.*

THE BASIC SETUP

During each of the methods of transferring slides, artwork
or movies to video, we will use a TV set in place of the
camcorder's viewfinder. This makes focusing and color bal-
ancing much easier.

Here are the basic steps:

1. Place the camcorder on a tripod.
2. Attach a cord from the video output of the camcorder
 to video input of the TV.
3. Aim the camera at the slide or artwork.
4. Place the camcorder in the standby mode. Watch the
 screen as you adjust the camcorder for picture area,
 focus and color balance.
5. Zoom to telephoto for manual focusing; then, zoom back
 to the desired picture area.
6. Trigger the record mode.

SHOOTING PROJECTED SLIDES

Although the slides don't show motion, a fast sequence of still
images can be used to make up for missing video footage. Slides,

ADDING SLIDES AND GRAPHICS

combined with titles and inserted between video action se-
quences, add interest and variety. The taped images won't be
perfect. However, if you're desperate to add slides to video,
shooting projected images will work.

The simplest method is to "shoot slides off the wall." Be-
cause beads or patterns on some screens reduce image quality,
project slides onto a sheet of flat white art or poster board
attached to a wall. A projected image about 18 inches high is
ideal. If the image is larger, the dim light will produce a poor
recording. If the image is smaller, hot spots and imperfections
will be more apparent. Keep the projector and camcorder as
close together as possible to avoid distorting (keystoning) the
images. Look at the image on the TV set. If contrast is too
great, place a small light at the back of the room.

VIDEO CONVERTERS

These accessories, available from several manufacturers, are
used to convert color slides, movies and color negatives to
video images. Some video converters attach to the accessory
threads of the camcorder lens; others are placed, unattached,
between the slide or movie projector and the camcorder.

These systems use mirrors and frosted glass or plastic screens
to transfer the images. With some systems, the image is pro-
jected onto the screen, and a mirror behind the screen re-
flects the image to the camcorder lens. With others, the mirror
reflects the image to the screen, and the camcorder tapes the
image from the reverse side of the screen.

● ● ● ────────────────────────────────

*With video converters, the image must pass through a projector
lens, through a frosted screen and off a mirror. Each time the im-
age is processed, some image quality is lost.*

──────────────────────────────── ● ● ●

SLIDE-TO-VIDEO COPIERS

I prefer systems which allow you to shoot directly off the surface of a 35mm slide or negative, such as Sony's HVT-80 Film Video Adaptor, a specialized video converter. Other companies offer similar products.

The rear of the slide copying tube attaches to the accessory threads of the camcorder lens. The front of the tube attaches to film holders for mounted 35mm slides and negatives. A close-up lens inside the tube focuses the image for the camcorder lens.

Owner's instructions provide details about light sources. With the Sony HVT-80, for example, you can use a 100-watt frosted light bulb at about six inches from the front of the slide copier, or a light box at about three or four inches.

To avoid glare from the light source, you can make a cardboard shield. Cut a rectangular hole (about two inches square) in the cardboard and place the cardboard between the light source and the slide copier. Aim the copier through the hole in the cardboard.

NEGATIVES TO VIDEO

You can use the HVT-80 (and similar systems) to transfer color and black & white negatives to video. For best results, your camcorder (or video processor) should have a negative/positive reversing switch. If so, the color negatives are copied as color images. Color can be added to black & white negatives with color filters or a video processor.

MOVIES TO VIDEO

The process is basically the same as shooting from slides. You may have to experiment with different camcorder shutter speeds, and try both 18fps and 24fps with adjustable-speed projec-

A light box is an excellent light source for making video-to-slide and negative-to-slide transfers. Try a distance of three to four inches.

A variety of slide-to-video copiers are available. I prefer a system that allows the camcorder to shoot directly off the slide, such as the Sony copier shown here.

tors, to find the best combination. Sound can be recorded directly from projector to camcorder. Connect the audio line output of the project to the audio line input of the camcorder.

The 8mm movie adaptor included with the Sony HVT–80 Adaptor screws directly into the accessory threads of the camcorder lens. The movie projector projects images on a translucent screen located on the side of the movie adaptor. An internal mirror reflects the projected image to the camcorder lens.

SHOOTING TITLES AND ARTWORK

Titles can be typed, but home computers do a better job–especially if you have a laser printer. The fewer and larger the words, the easier the title will be to read. If you must have long titles, don't use more than 10 lines of text or 24 characters per line. Drawings should be bold enough to show up on the TV screen. Photographs can be either color or black & white.

Attach the artwork to the wall (a bulletin board works fine), and use a small level to make sure the camcorder (mounted on a tripod) is aligned squarely with the artwork. Place a pair of lamps to the left and right of the artwork for even illumination. Experiment with different white balance settings as you watch the image on the TV screen.

Mount the camcorder on a tripod when shooting titles and artwork. Two lights at 45-degree angles, (one on the left and one on the right) are recommended, but you can use any even light source.

The Ghost Fleet of Truk Lagoon

··· 19 ···

PLANNING
THE FINAL EDIT

Every minute of shooting can require ten or more minutes
of planning and editing. Every minute of edited videotape
can require ten or more minutes of shooting.

PLANNING YOUR PRODUCTION

Is the purpose to instruct or to entertain? Is there a definite story line, or is it a montage? Define your purpose before plunging in!

ORGANIZE EXISTING FOOTAGE

Because your best shots are probably scattered over several videotape cassettes, your first job is seeing exactly what you already have.

Watch each tape from beginning to end. You'll be surprised at how many good scenes have been forgotten or overlooked. Use a notebook (or computer file) to log scenes. Set up columns for tape numbers, start and stop points on the time/footage counter, and scene and/or action descriptions. If you have a menu-driven video editing controller, give scenes short names that you can input into the editing program. Take accurate notes now, or suffer needless frustration later!

MAKE A STORYBOARD

Use index cards to make a storyboard, as discussed in Chapter 16. Lay the cards on a table top and see what scenes are missing. Sketch new scenes (which you need to shoot) on color-coded cards and add these to the deck. Fancy artwork isn't

A storyboard can be made with simple drawings on index cards. See what scenes are missing, and sketch needed scenes on cards.

necessary; stick–figure sketches are fine. If you want to show an action, such as fish feeding, but don't know how many divers will be involved, simply write "fish feeding" on a blank card.

MAKE SPECIFIC SHOT LISTS

While the story board gives an overall view, a shot list organizes those shots you will take during a specified dive or dives. I use specific shot lists, written on white tape and attached to my video housing. A typical shot list might be as follows:

 LS: Divers approach eel's lair.
 CU: Cut–in to eel's face.
 MS: Divers closer to eel's lair.
 CU: Cut–in to one diver's face.
 CU: Views of eel's face.
 LS: Divers leave area.

If you will be adding titles, graphics or special effects, make cards for these additions. Although it's best to plan basic special effects shots ahead of time, your best ideas often occur later.

MAKE A PRELIMINARY EDIT

Make a preliminary rough edit to get a feeling for the content and timing of your video movie. Don't get bogged down trying for perfection. Editing controllers allow you to add, delete or rearrange scenes; if you have one, fine tune later. The same idea applies to simple editing with only a camcorder and VCR. It's only a preliminary edit.

Attach final shot lists to the back of the camera housing. You can use plastic tape and a laundry marker.

TITLES AND EFFECTS

Don't even think about adding titles, wipes, fades and other special effects until all other scenes are selected. If you have an editing controller or equalizer, read the instructions carefully and do each step in its proper sequence! Break the sequence, and you often must start over again.

WHAT ABOUT AUDIO

Music and voice-over narration are usually added near the end of the editing process. However, some videographers add sound to different parts of the tape during the edit, or edit video onto a tape with prerecorded audio. Others add sound to the final tape after the video has been recorded.

Specifics vary with the equipment available. If you add sound to the original tape with the audio dub control, disengage the audio dub whenever you wish to preserve live sound that was recorded with the video. Otherwise, the live sound will be erased and gone forever. The safest method is to add extra sound to the edited dub, not to your original tape.

WORK STEP BY STEP

The processing of shooting a video movie can be summarized in the following steps:

1. Begin with an overall plan.
2. Organize the footage you already have.
3. Use index cards to create a storyboard.
4. Decide what additional shots are needed.
5. Make specific shot lists.
6. Make a rough edit for sequencing.
7. Shoot titles and graphics.
8. Make the final edited tape.
9. Add music and narration.

The exact order of the above steps may vary, depending on what editing and audio equipment you have. Steps 6 and 7 may be combined or repeated. Follow the steps in order; skipping steps usually causes problems.

Visual Continuity

Good visual continuity flows smoothly from scene to scene. The following tips will help maintain visual continuity:

- Use the LS (long-distance shot) to MS (medium-distance shot) to CU (close-up shot) to lead viewers from the overall scene to specific actions.
- Change image size (LS, MS and CU) and camera angle frequently. Several different views of the same subject will be more interesting than one long view.
- If a shot doesn't support the story line, don't use it. A shot that just fills space will bore viewers.
- Use fast cuts unless you are implying a beginning, ending or transition. Use fades, wipes and other special effects to imply changes in time, location, etc.
- Fill the screen with the subject. After using a LS to introduce a setting, move in for MS and CU shots as soon as possible. The TV screen is small and needs to be filled with close-up views of the subject.
- Avoid arbitrary changes in screen direction. Use changes in screen direction to signal changes in actions or subjects, and beginnings and ending of sequences.
- Ten minutes is usually enough! A video movie that is too long won't maintain viewer interest. Most half-hour TV programs only have about 22 minutes of actual story. This should tell you something!
- Resolve strong action. If an action is started but isn't finished, the action will be confusing to view. For example, suppose you show a diver looking into a goodie bag. If you pan away and never show the diver again,

the viewer is left wondering what was in the bag. You could, however, use this shot to build suspense. Then, reveal the contents of the goodie bag later to resolve the action.

● ● ● —————————————————————————————

When you make your first video movie, remember to KISS—keep it super simple. If you are struggling with a confusing owner's manual, or constantly changing your mind about what scene or special effect to use next, video editing will be a nightmare. Keep your first video production as simple as possible. Learn how to push the button first; get creative later!

————————————————————————————— ● ● ●

··· 20 ···

MAKING
THE FINAL EDIT

This chapter will guide you through the final editing for your underwater video. We'll explore the ideas and techniques you'll use with most home editing systems.

PRE–EDIT PRACTICE

Before starting a major editing effort with new equipment and using splashy special effects, make a short practice edit first! Start with three or four 30-second scenes, and add some graphics and titles. These scenes should be enough to practice all your editing techniques. Don't use any more scenes than necessary! Limiting yourself to about two minutes of edited video can save hours of time and effort while you are learning.

Follow these steps:

1. Practice finding and marking the cut-in and cut-out points for each scene.
2. List every title, graphic and special effect that you wish to use. Add sample graphics to the practice scenes.
3. If adding sound, calibrate the audio input levels.
4. If you have a video processor, note and mark the settings which give the best results.

Don't skip any of the above steps! If you get lost and must start over again, you'll be glad you learned with a two or three-minute tape rather than a 10-minute production.

LABEL AND TAKE NOTES

Your work station will soon become a jumble of videotape cassettes, dubbing cables and equipment with tiny switches. Label each cassette, and if multiple sets of dubbing cables must be plugged and unplugged during the editing, label the ends of the cables. Likewise, if there are small switches that must be located and activated quickly, use small pieces of bright tape to mark their location.

Write the steps of your editing plan in a notebook before you start. Check off each step as you do it. If you vary the steps in any way, write down exactly what you did! Otherwise, you might make the "Church mistake." You'll return from a coffee break and discover you've forgotten where you left off! If you have a computer word processing program, open a "notebook" file and key in changes as you work through the editing steps.

DUB THE ORIGINAL

Make a dub of the original tape. Then, use the dub to make a rough edit. This reduces wear-and-tear on the original as you fast forward and rewind to find and mark scenes.

When searching for marked scenes, some editing controllers can't handle large spaces of unrecorded blank tape between scenes. Blank spaces are caused by fast forwarding between scenes, and usually happens when the videotape is removed from the camcorder between shooting sessions for viewing. To avoid blank spaces, allow the camera to run for ten seconds or more (recording anything, even your lens cap) between shooting sessions.

MARKING THE SCENES

Think GIGO (garbage in, garbage out) when you mark scenes. If the edit control is menu-driven, and prompts you to name

each scene, make a list of short names (one to three words) for each scene. Don't allow the edit controller to name scenes as, "Scene 1, Scene 2, etc.," and don't use non-descriptive names. Otherwise, you will never remember what the scenes contain when you start moving them around, and adding titles and graphics.

ADDING TITLES AND GRAPHICS

If your editing controller has a built-in character generator to add titles, standardize with a few type sizes and fonts (styles), and color combinations. Continuity of type styles will make your video appear more professional.

Use graphics and other special effects sparingly, or they will become distracting. Likewise, fast fades and wipes are usually better than slow ones. Learn by watching commercial programs. Notice how most scene-to-scene transitions are fast cuts. Use slow fades and wipes sparingly to mark major transitions in time or location.

Script your titles before entering them into the character generator.

Some editing systems have on-screen menus to help you mark scenes, and add titles and graphics.

ADDING AUDIO

Your editing controller may have audio inputs for adding music or narration. If you add audio during the editing process, you could have a continuity problem. If the controller stops the main VCR (on which the edited tape is being made), you will have abrupt changes in the music.

You can program some edit controllers to regulate audio input. When a scene starts, the controller fades the audio in; when a scene ends, the controller fades the audio out. This eliminates abrupt breaks in the audio, but the music jumps from one part to another.

Adding audio last may be your best option. With the VCR in the audio dub mode, you can add music or narration as you watch your edited video on a TV screen. However, if you accidentally record over any live narration that is on the tape, you lose it forever! The audio dub mode erases and over-writes whatever sound is on the videotape being played or dubbed.

PART
··· 5 ···
APPENDICES

A

GRAND CAYMAN VIDEO GUIDE

"What should I shoot," you ask the dive guide before your first dive on Cayman's North Wall. "Anything and everything," he replies. "There's all kinds of stuff here."

Your travel arrangements are made, your video system is checked and ready to go, and you're anxious to begin videotaping the undersea wonders of Grand Cayman. You want to videotape this exciting dive vacation, but you are anxious. What video subjects await you, and how will you tape them?

VARIETY IS THE GAME

Variety is the name of the game in Grand Cayman. The undersea menu includes magnificent walls and the pelagics they attract, friendly fish, southern sting rays and two crumpled shipwrecks—the Oro Verde and Balboa. There is so much to see and videotape—a shark or eagle ray may glide by the wall any moment—that your brain can turn to mush.

To use your camcorder effectively, plan ahead and shoot as follows:

- Take some stock shots. These include your hotel, the shore activities, the dive boat, gearing up, and divers entering and exiting the water. These shots can be edited in later to punctuate your underwater sequences.
- Concentrate on the strongest features of each dive site: At a sheer wall, capture the feeling of the wall plung-

ing down for thousands of feet. If friendly fish are the main attraction, capture their antics on videotape. When shooting corals and sponges, concentrate on recording their rich yellows, oranges and reds.

If you shoot blindly at whatever appears before your video camera, your video movie will be choppy and disjointed. Don't get sidetracked with shots of your dive buddy clowning around when the stingrays are approaching!

THE WALLS OF CAYMAN

For maximum interest and variety, shoot all three basic camera angles: downward, level and upward. This advice applies to all the walls of Westbay, North Side and Bloody Bay in Little Cayman.

For downward angles, try approaching the wall's edge at an angle of about 45 degrees. Start shooting about ten feet from the edge, and continue shooting as you swim over the edge and angle downward. (This takes your viewers over the wall with you when they watch your exploits on a TV set.) If there are divers below you, their bubble streams will enhance the shot. Don't use a video light. Most subjects will be out of the light's range, and the light may illuminate particles in front of the lens.

For level and slightly upward camera angles, begin by looking for corals and sponges protruding out from the wall. Use these as frames to accent distant divers. If you have a video light, get within three feet or less of these framing corals and sponges so the video light will brighten their colors. A distant diver, for example, looks great silhouetted over a brightly illuminated orange elephant-ear sponge.

For upward shots toward the bright sun, don't tilt upward so the dark silhouette of the wall fills the center of the picture area. If so, the brighter surface area in the upper portion of the video picture will burn out. For best results, tilt up to an area of average brightness.

Orange, elephant-ear sponges often grow on the walls of Cayman. Use your video light to illuminate the sponge.

When shooting outward from the many tunnels and crevices in the wall, the bright openings will burn out easily. Take these shots during overcast days when the brightness range between the dark sides of the crevices and the bright openings is reduced.

If you plan to shoot below 60 feet with subjects further than about four feet away, remove the color-correction filter. It loses effectiveness with both depth and distance, and only holds back light which reduces depth of field. Set your camcorder for the wide-angle and outdoor settings.

SPONGES AND CORALS

For close shots (less than three feet), set the white balance for indoor and remove the filter. The darker the ambient light, the greater the effect of the video light. Colors and details will be enhanced.

In bright sunlight, or at distances greater than about three feet, set the white balance for outdoor and use the filter.

If you don't have a video light, set for outdoor white balance and use the filter. Try to separate sponges and corals from their backgrounds by silhouetting them against blue water. If you can't isolate subjects, look for other colorful subjects against drab, non-competing backgrounds.

STINGRAY CITY

Before jumping into the water to shoot the rays at Stingray City, listen to the dive briefing carefully and consider the following facts:

- The rays are there for one reason: they want food. They will nudge, slide over and otherwise harass any diver who has baitfish.
- Most newcomers to Stingray City are excited and usually kick up clouds of sand.

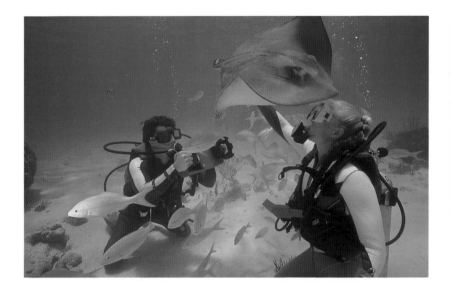

The rays of Stingray City offer interest and action for videomaking. Filters and video lights aren't needed. Photo: Mike Mesgleski.

Don't carry baitfish while shooting the rays. Shooting other divers covered with rays is much easier than attempting to shoot as you fend off the rays. Don't worry, you'll get stingray close-ups; plenty of rays will buzz you and your video camera.

Stay on the fringes of the group. If you are in the center, you'll find yourself in the middle of an undersea sandstorm. If you're in the center, shoot upward shots showing rays passing overhead in silhouette.

Because twenty minutes of videotaped stingrays can all look the same, vary your shots. Shoot the following:

- Get a shot of one or two rays approaching, without background divers. This is the underwater introductory shot you can use to start your stingray sequence.
- Shoot two or more map shots. Get up near the surface and show a downward view of the rays gliding around and over the divers. This gives the viewer an overall "map-like" view of the scene.

- Shoot several medium–distance action shots, with level or slightly upward camera angles. Isolate individual divers interacting with rays.
- Take some upward angle silhouettes of rays passing overhead. This adds variety by presenting a different view.
- Get some close-up shots of rays swooping toward you with their mouths open.
- End with a view showing one or more rays as they swim away. This gives you an ending for the stingray sequence.

You don't need a video light; unless it's extremely overcast, sunlight is all you need. The depth is only about 12 feet and the sand bottom reflects light upward to the shadow areas. Opinions regarding filters vary. I suggest removing the UR/PRO (or other reddish filter) because it makes scenes too colorful. If the filter is in place, set the white balance for indoor. The indoor setting reduces the reddish effect of the filter.

THE *ORO VERDE*

Resting at 60 feet, the *Oro Verde* is no longer intact. Only the bow bears a distinct resemblance to a shipwreck. Begin with a shot of the bow, at a slight angle, to establish that you are on a shipwreck. Then, move in and shoot tighter scenes of the sea life living in and around the wreck.

Thousands of silversides (tiny, silvery fish) often school inside enclosures formed by the wreckage. If you can find an enclosure large enough to get inside, or shoot through, the silversides look great in silhouette.

Several large groupers, jewfish and eels live in the *Oro Verde*. If you don't chase them they will often swim up to your camera lens. If possible, set for indoor and remove the filter if you are using a video light. If you don't have a light, try to shoot these creatures when they are out in the open, not while they are in dark recesses in the wreckage.

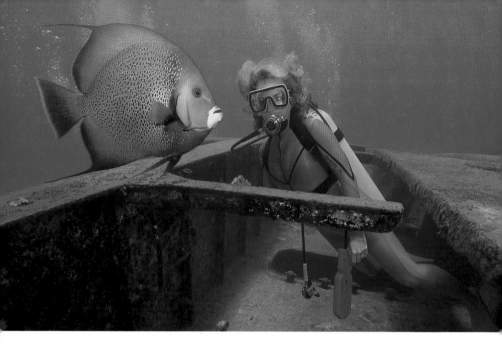

The Oro Verde *abounds with friendly fish, such as this inquisitive angel.*

The *Oro Verde* "begs" for downward map shots. Use these down-ward long-shots as cut-away shots to punctuate the closer action and re-establish the location for your viewers.

Because the *Oro Verde* has potential for both long distance and closer shots, divide your video taping into two dives. Concentrate on long shots during one dive. Set the white balance for outdoor and don't use the video light. Then, move in for your closer shots during the second dive. If you have a video light, set the white balance for indoor and remove the filter. If you don't have a light, set the white balance for outdoor and use the filter.

THE *BALBOA*

The *Balboa* went down in a hurricane in 1932, and rests in 30 feet of water in Georgetown Harbour. At first glance, she appears to be a junk pile. But if you look closer, the *Balboa* offers numerous opportunities for underwater videographers.

Her prop is high enough for shots with clean, midwater back-grounds, with and without divers. Go into the capsized hull section and look upward. You will see mirror-like reflections in the airpockets trapped in the overhead. Look through the section known as the "pup tent," and you have an excellent frame for divers. Visit the boiler room, and you will find a variety of close-up critters.

The *Balboa* is, in my opinion, Grand Cayman's finest night dive. You can find octopus, lobster, sleeping fish, arrow crabs and banded coral shrimps galore.

FRIENDLY FISH

No video story about Grand Cayman is complete without shots of fish antics. At many dive sites, the grouper will move in and inspect their reflected images in your dome port. Grace-ful French and gray angels will glide by, and eels will peer out of their lairs.

You will shoot most fish shots at distances of about one to three feet. If you have a video light, set the white balance for indoor and remove the color-correction filter. If you don't have a light, set the white balance for outdoor and use the filter. Hold your video camera as steady as possible. Let the fish do the moving. If you pan with a moving fish, follow its general line of travel. Don't try to follow every single movement.

A timid octopus tries to blend in with the sandy bottom during a night dive on the Balboa.

··· B ···

LIVE-ABOARD
VIDEO GUIDE

*"But the brochure said that video equipment was available,"
you tell the Captain. "Yea, but that brochure was written last
year, by the stateside office," is his reply.*

PROMISES, PROMISES

If you will be renting equipment aboard the vessel, make
sure that you reserve the equipment ahead of time and get
written confirmation before sending your check. Some live-
aboards have ample inventories of photo equipment aboard,
and will be happy to accommodate you. Sometimes you may
have to share some equipment, such as video lights, with others.

Some live-aboard operators consider video equipment rentals
a necessary evil. The equipment is expensive and can be abused
by inexperienced divers. Repairs are also a problem if the boat
is in a remote area. The vessel's only video light may be bro-
ken (Gosh, we forgot to tell you!), or you may have to share
the video camera with other guests. Again, if you plan to rent,
make rental agreements early and in writing!

If you want video instruction, ask who the instructor is, and
what other duties the instructor has. Vessels with strong pho-
tographic programs will have a crew member designated as
the photo pro, and may periodically have visiting professionals
teach special courses. If the vessel doesn't have a strong photo
program, the "instructor" may be an inexperienced videographer
burdened with other shipboard duties. Find out ahead of time,
or the blind may lead the blind.

Make a Shot List

Your underwater subjects will vary with the vessel's location, the dive sites and the divemaster's knowledge of the sites. In addition to the specific video opportunities the vessel offers, I strongly recommend listing and shooting some stock footage that you can use when editing your tapes at home.

Topside stock shots are often ignored while at sea, but become extremely valuable after the trip, when you are editing your final story. Thus, the topside list should include the following:

- Views of the vessel at the dock and sea. Ask the captain to arrange a dinghy ride so you can shoot the vessel from several angles.
- Several long and medium distance shots of the dive deck, dive platform, gearing up and entering the water.
- A variety of shots showing your cabin, the dining and lounge areas, mealtime, and sunbathing on the upper deck.

Get a shot of the live-aboard from the vessel's dinghy. This gives you an establishing shot to introduce viewers to the vessel.

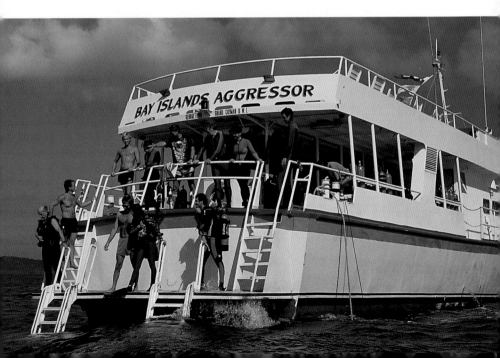

Shoot some topside activities, such as your dive group enjoying a meal on the upper deck.

- The divemaster giving his dive briefing, plus a close view of the chalkboard.
- Short interviews with the captain, divemaster and other important crew members.
- Interesting incidental shots (for cut-aways) of the ship's cat, ship's flag or any other opportunity shot such as a bird perched on the rigging.

Group your topside shots. Devote part of one morning and part of one afternoon specifically for topside shots, and your life will be easier. You won't be taking the camcorder in and out of the housing, again and again (and forgetting to set one critical switch or control). You won't be restricted to shooting topside shots through the housing's dome port, and you won't be handling the camcorder with wet fingers.

While you will probably be anxious to shoot the underwater action, you should have some stock shots on tape. Shoot stock shots whenever the dive boat visits a dive site that offers few other video opportunities. Add the following stock underwater shots to your list:

- An upward view of divers descending with the silhouette of the vessel above.
- Rest the camera on a tripod or rock (not a coral head) and take some shots of yourself swimming from left to right, and from right to left. These can be used for transitions.
- Shoot some close-ups of diver's faces, and some shots of rising bubbles. These can be used for cut-aways.
- Shoot some shots of divers swimming back up to the boat. These can be used for endings.

Most live-aboard captains present an overall plan of the week during the introductory briefing, and a map of the area is usually posted. Start planning and listing your shots immediately!

··· C ···

TRUK LAGOON
VIDEO GUIDE

Fish, colorful corals, historic wrecks and artifacts—they all lie beneath the dive boat. There is so much to videotape that you don't know where to begin.

SELECTING THE WRECK

This can be a problem. I heard one dive operator brag: "You'll see twenty different wrecks in twenty dives." This is great for tourist divers, but tough for serious underwater videographers.

For best results, try to dive fewer wrecks and repeat those with the best video potential. Use the first dive for your long shots and to look around. Come back for your close shots of corals and artifacts.

Read about the wrecks ahead of time and listen carefully to the dive briefs. Then, get to your specific shot locations quickly, before other divers kick up the sediment.

PLAN TO EDIT

Although many underwater videomakers like to edit in camera, this can be difficult in Truk Lagoon. Because you don't always know when action will begin, start shooting a few seconds early. If you are uncertain when the action will end, keep shooting. I recently relearned these lessons the hard way. I edited in camera while shooting. When I decided to edit later, many of my shots were difficult to cut because there wasn't enough space between my best shots.

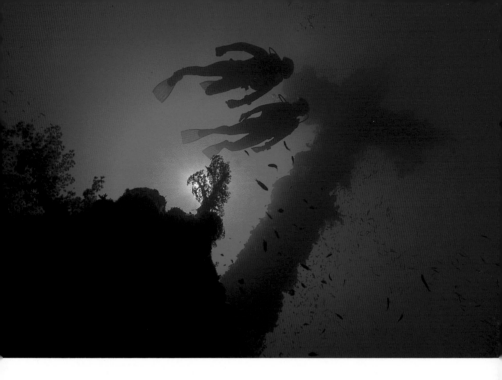

An upward angle LS, with a ship's mast in the background, sets the stage for the exploration that will follow.

LONG SHOTS

You need long, scenic shots to set the stage and show the larger artifacts. Move away from the wreck to show perspective, especially when shooting bow shots. Downward shots can show the gaping maws of open holds. Level or slightly upward or downward shots can record superstructure, deck guns, or tanks and trucks on sunken decks. The artillery pieces and tank on the deck of the *Nippo Maru's* deck, and the trucks on the *Sankisan Maru*, are excellent long shot subjects.

If possible, remove your color-correction filter for long shots. The filter loses effectiveness when used for long shots in deep water. Removing it increases the amount of light passing through the lens, which increases depth of field. Set for outdoor color balance and shut off your video light. The scenes will be bluish or bluish green, but that's the natural color of distant subjects.

Slow tilts–from level views of a deck to upward views of superstructure–can cause contrast problems. The top of the picture may burn out when the automatic exposure control sees the middle range of contrast during the moving tilt. To compensate: (1) set the iris override or gain control for partial underexposure, or (2) avoid tilting up to bright areas.

MEDIUM DISTANCE SHOTS

For medium distance shots of divers and artifacts, set for outdoor and use your video light for fill. The goal is a sunlight exposure with movie light fill. With a color-correction filter, don't get too close or the combination of video light and filter can make images too red.

For interior shots, reset the white balance for indoor. Try to avoid shooting scenes with open doorways in the left or right of the picture, outside the automatic exposure control sensing area. Otherwise, the bright openings will burn out.

Medium distance shots of the baths in the *Shinkoku Maru* can create lighting problems: Video lights tend to create a hot spot in the center of the wide-angle picture area. I place a SB-103 strobe diffuser in front of the video light to spread the beam. If you don't have a diffuser, have a buddy hold your light back to spread the beam.

The zero fighter fuselages in the *Fujikawa Maru's* hold are good subjects for both long and medium distance shots. Try to shoot when the sun is high so sunlight penetrates the 90-foot depth of the hold. If you have two video lights, have your buddy hover overhead and aim one light straight down into the zero's cockpit. If a third light is available, aim it into the open rear of the fuselage to backlight the pilot's seat and help illuminate the inside of the cockpit. Please don't sit in the cockpit; it's getting old and fragile!

The reflective tiles of bathtubs can cause hot spots. Use diffusers and hold your video light back to spread the beam.

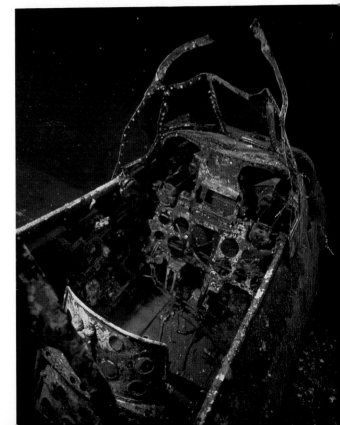

The Zero cockpit will make old hearts beat faster. Two video lights—one aimed downward by a hovering buddy, and another from the left of your camera, work well.

Close-Up Shots

Dishes, typewriters, gas masks or ship's lanterns are good subjects, day or night. If you prefer sea life, strawberry tree corals, gorgonians, finger corals and broccoli corals cover the exteriors of many ships. Set the white balance for indoor and use your video light. When shooting close-ups in bright sunlight on shallow parts of wrecks, the outdoor white balance may be best.

Protect the Artifacts

To some, a pile of old dishes, a gas mask or piles of ammunition are just so much junk. But to others, the artifacts are historic reminders of the past. Please view and shoot artifacts in their natural state–don't handle, move or otherwise damage them.

During my many trips to Truk Lagoon, I've seen cumulative damage caused by careless divers. This damage isn't just from fins; it's from repeated handling of delicate artifacts and jamming oversized buttocks into the narrow confines of Zero cockpits. Only a few years ago, the *Sankisan Maru's* forward hold was filled with box after box of machine gun bullets. Today, most boxes are smashed and the bullets scattered around.

Well-meaning local dive guides, eager to please tourist divers, may cause much of the damage. Please don't encourage them to gather and line up artifacts for your inspection. Ask them to show you artifacts in their natural state.

··· D ···

GLOSSARY

Angle of view (angle of acceptance). The angle that the camera lens "sees." Usually measured diagonally from corner to corner.

Aperture. The width of the iris opening that admits light to the electronic sensing device.

Assembly editing. To select and arrange the order of video scenes while editing.

Audio dubbing. To add an audio track to a videotape without disturbing the video track.

Audio in. The port on a camcorder or VCR that receives audio.

Audio. Sound.

Audio track. The portion of a videotape used to record audio—music and/or narration.

Autofocus. A built-in system that automatically selects the correct focus (distance). TTL (through-the-lens) autofocus systems work better for underwater videography than sonic or infrared systems.

Autolock. A camcorder control that locks camcorder features, such as white balance focus, in (or out of) the automatic mode.

Camcorder. A video camera with a built-in VCR. This VCR is usually called a VTR.

Camera. As used in this text means a camcorder or video camera, with or without an underwater housing.

CCD. Charged-coupled device. The component that senses the images and converts them to electrical signals.

Character generator. An accessory (built into some camcorders and editing controllers) that electronically generates letters and numbers which are recorded on videotape.

Chroma (chrominance). The color portion of a video signal.

Composite video. Signals for chroma (color) and luminance (brightness) are combined in one signal. VHS and standard

8mm use composite video. (S–VHS and Hi8 camcorders can also record and playback composite video.)

Continuity. (1) The flow of action in a video movie. (2) Maintaining sameness in dress and screen direction.

Contrast. The difference between the brightest and darkest areas in a scene, picture or video image..

Control track. An electronic signal recorded on video tape. It tells the playback VCR how fast to play the tape. The control track to video tape is like sprocket holes to movie film.

Conversion lens. A supplementary lens that is placed in front of the camcorder lens. Some conversion lenses increase the angle of view (wide–angle); others decrease the angle of view (telephoto). Some are reversible for either a wide–angle or telephoto effect.

CU (close–up). A close shot that pinpoints a small picture area. LS and MS shots often lead to CU shots.

Cut. An instantaneous change from one image (or sound) to another. Cutting is a commonly–used editing technique

Cut–in shot. A brief CU or ECU that cuts into the main action. For example, if an MS shows a diver reading a depth gauge, a brief cut–in CU can show the diver's view of the gauge.

Delete editing. To edit by deleting unwanted scenes.

Depth of field. The area in front of the camera–from a minimum distance to a maximum distance–in which your subjects will be acceptably focused.

Dew (warning or switch). A warning signal in the viewfinder and/or switch that turns the camcorder off if the tape or electronics are damp with condensation or humidity.

Dissolve. To fade from one image into another. (Also, see Fade.)

Dome port. A housing port with a half–hemisphere shape.

Dropout. A small, fast spot of light that passes across the TV screen. Dropouts are caused by a bit of missing oxide on the videotape.

Dub (dubbing). A copy of a video or audio tape (noun); the act of copying a video or audio tape (verb).

ECU. Extreme close–up shot.

ED–Beta (Extended Definition Beta). A high–quality Sony videotape format.

Edit. To choose and/or rearrange scenes in a video or audio

track. (Also, see Insert editing and Delete editing.)

Edit controller. An accessory that controls two VCRs (or a camcorder and a VCR) during editing. Edit controllers "remember" selected scenes and assembles these scenes during the edit.

Edit switch. A switch on a camcorder or VCR that bypasses some playback circuits during dubbing. This produces cleaner dubs.

Electronic viewfinder. A viewfinder that shows the subject's image on a miniature TV screen.

Establishing shot. A shot, usually a LS, that introduces the viewer to a scene or action.

Fade. To dissolve from black to an image, or from an image to black. Many camcorders have a fade control. Some editing equipment will allow you to fade to and from colored backgrounds.

Filters. Colored optical glass or gel. Their purpose is to alter the color of light passing through the filter. Glass filters are in metal mounts that screw into the accessory threads of the camcorder lens.

Flat port. A flat glass or plastic "window" in a video housing.

Flying erase heads. Special heads that allow you to start, pause, and start a camera or VCR without causing unwanted flashes of color and other video noise.

Focal length. The distance from the optical center of the lens to the image sensing device. For practical purposes, focal lengths give an indication of angle of view.

Focus. The adjustment for camera–to–subject distance. A picture taken with proper focus will appear sharp on a TV screen.

Frame (picture area). The area with the angle of view, or within the picture area. Example: The fish swam into the frame (into the picture area).

Full–range autofocus lens. A camcorder lens that can be focused from less than a inch to infinity, while in the autofocus mode, without a special macro adjustment.

Gain control. An electronic control that increases or decreases the video signal (to prevent under- or over-exposure).

Generation. A term used to indicate how many times a video

or audio tape has been copied. The original videotape is first generation. The first copy is second generation; the second copy is third generation, etc.

Glitch. Static or other video noise that appears on the TV screen.

Headroom. The space between the top of the subject and the top of the picture area. When shooting divers, for example, avoid having the tops of their heads bump against the top of the picture.

Hi8 (Hi-8, high-band 8mm or hi-band 8mm). An enhanced version of standard 8mm with higher resolution than standard 8mm.

HQ. High-quality circuity. Advertising claims and varying standards have made this a meaningless term.

In-camera editing (editing in camera). Shooting scenes in the order in which they will be played back.

Insert editing. To add a new shot which is placed over one or more existing shots.on a videotape.

Iris. The metal blades which form the opening that admits light through the lens.

Iris override. A manual control that can increase or decrease the iris opening selected by the automatic exposure control.

Lens speed. The ability of a lens to admit light. A "fast lens" has a wider aperture and gathers more light in dim conditions.

Lines of resolution. See Resolution.

LS (long shot). A long-distance shot, usually wide-angle, showing an overall view of the scene. The LS is often used as an establishing, transition or resolving shot.

Luminance. The black and white portion of a video picture. It is the "Y" half of a YC (S-video) input or output.

Lux rating. A measurement of how much light is needed to record an image. The lower the Lux rating, the lesser the amount of light required.

Map shot. A downward, wide-angle view that shows the relative positions of subjects.

Master VCR. See Playback VCR.

Macro. Extreme close-up.

Macro mode. A setting, usually activated by pressing a but-

ton on lens, that allows standard lenses to focus from less than an inch to about four feet.

Mixer. An editing accessory that mixes (combines) several audio or video inputs and blends them into one.

Monochrome. Black and white images.

Monitor (monitor/receiver or TV/monitor). A television set with special inputs and outputs for playback directly from a camcorder or VCR, in addition to the normal cable input. (Hi8 or S-VHS tapes can be viewed on a TV set without S-video inputs if the composite input is used. You won't, however, see the full advantages of S-video resolution.)

MS (medium-distance shot). A medium-distance shot that provides the transition between an LS that established a scene, and the CU which will follow to pinpoint the action.

Nickel-cadmium (nicad, ni-cad). A rechargeable battery commonly used to power camcorders and video lights. Nicads usually last for 500 or more charge and use cycles.

Noise (video noise). A brief or continuous interference or interruption of picture or sound.

Normal lens. A lens with an angle of view that approximates that of the human eye.

Nose room. The space between the front of a moving subject and the side of the video picture area. For example, the nose of a moving fish shouldn't "bump" the edge of the picture.

Overlap (overlapped action). To reshoot the same action that occurred at the end of the previous shot, but from a different angle.

Pan (Panning). Moving the camera from left to right, or from right to left while shooting.

Parallax. The difference between the line of sight of an accessory viewfinder and the video camera lens. These lines of sight should meet at a predetermined or preset distance in front of the camera.

Plant. To introduce the viewer to a subject that will become important later in a video story. For example, a quick cutaway to an object that a diver/model is searching for.

Playback VCR (main, master). The VCR used to play the original tape during editing. Often, this is the camcorder's built-

in VTR.

Postproduction (post-production). Video or audio editing after the original tape is shot.

Record (recording). To place video images (by shooting or dubbing) on videotape; to place audio (with a microphone or other audio source) on video or audio tape.

Refraction. The bending of light rays as they pass through the water/glass/air interfaces of a flat lens port. The effect is to reduce the underwater angle of view to two-thirds the angle of view in air.

Resolution (lines of resolution). Image sharpness as measured in the number of horizontal lines visible in a given picture area. The higher the number of lines, the finer the details recorded or seen.

Resolving shot. A shot that shows or implies the end of an action or series of related shots. The resolving shot may also provide the transition to the next action.

Scene. (1) The overall view of a subject or subjects, from the camera's viewpoint. (2) A shot or series of related shots recorded on videotape.

Screen direction. The direction action flows across the TV screen.

Sequence. A series of related shots in a logical order. A video movie is made of a series of related sequences.

Shoot (shooting). The act of recording a scene with a camcorder or video camera (verb); a session during which several shots are made (noun).

Shot. (1) The time from when your turn the camera on until you turn it off. (2) A single view of a scene recorded on videotape.

Silhouettes. Dark shapes and figures against light backgrounds.

Standard 8mm. (As used in this text.) The first 8mm format introduced. I use the term "standard 8mm" to differentiate 8mm from Hi8.

Standard lens. A camcorder lens that focuses from approximately four feet to infinity. Most standard lenses have a macro setting for close-up focusing.

Storyboard. An illustrated plan, in a notebook or on index cards, with sketches and notes, for a video production.

S–VHS. An enhanced version of VHS.

S–VHS–C (Super VHS compact). The S–VHS format packaged in smaller video cassettes for use with S–VHS–C camcorders.

S–Video. Enhanced versions of regular formats. Examples S–VHS vs. VHS, and Hi8 vs 8mm. Resolution is increased from less than 300 lines to 400 or more lines.

S–Video connectors (S–jacks, S–Video inputs/outputs, Y/C connectors). Special connectors on a camcorder, VCR or monitor receiver for S–VHS, Hi8 or ED Beta. Chrominance and luminance information is separated to eliminate crosstalk (mixing of the signals).

Special effects. Catch–all terms for fades, dissolves, slow motion, freeze-frame and other unusual effects.

Take. To attempt to videotape a shot. "Take one" would be the first attempt; "take two" would be the second attempt.

Taping (videotaping, shooting). See "Shoot."

Telephoto lens (telephoto). (1) A lens that gives a close–up view of distant subjects. (2) The longest zoom setting on a camcorder lens.

Tilt. Changing camera angle, either up or down, as you shoot.

Time–base corrector. A device that corrects timing variations in a video signal. Time–base correction reduces picture jitter and dropouts.

Title (titles). Words or numbers appearing in a video movie. Titles can be shot from printed title cards or paper, or can be generated with character generators.

Transition shot. A shot that leads the viewer from one location, scene or action, to another.

VCR. Video Cassette Recorder. It records and replays videotapes.

VHS (Home Video System). The standard one–half inch videotape format used in most home VCRs.

VHS–C (VHS compact). The standard VHS format, but packaged in smaller video cassettes for use with VHS–C camcorders.

Video camera. A camera without a built-in VCR. New video cameras (for general consumer use) are no longer available for the consumer market. They have been replaced with camcorders.

Video cassette. A plastic container which holds videotape.

Video cassettes are available in different versions for different tape formats, such as 8mm or VHS, and for different tape lengths.

Video controller. An editing accessory that electronically marks the beginnings and endings of video scenes and controls the playback and recording VCRs during editing.

Video processor. An editing accessory used for color correction, image enhancement and special effects such as fades, dissolves, character generation and audio mixing.

Video 8. Sony designation for standard 8mm.

Viewer. The person (or persons) who will watch your videotape on a television set.

Virtual image. An image focused in front of a dome port, by the curvature of the port. This image will be approximately 12 inches in front of the port, depending on the radius of the port.

Voice over. Narration added to a video by an unseen speaker.

VTR. Videotape Recorder, usually built into a camcorder.

White balance. Camera adjustment made to record white tones accurately in varying light conditions, such as indoor or outdoor. Most cameras have white balance control settings for indoor (video light), outdoor (sunlight) and automatic. Some have automatic white balancing.

Wide-angle lens. A lens with an angle of view wider than the angle of view of the human eye.

Zoom (zooming). Changing the image size (from wide-angle to telephoto) without changing camera-to-subject distance.

Zoom lens. A lens which is adjustable for a range of focal lengths from wide-angle to telephoto.

Zoom ratio. The change in focal length a zoom lens can produce. An 8x (8:1, pronounced "eight to one") zoom lens magnifies subjects when set for the telephoto position, as compared to subject size in the wide-angle position.

··· *E* ···

SOURCES
FOR UNDERWATER
VIDEO EQUIPMENT

No list of addresses can ever be complete. Small manufacturers enter and leave the market, and frequently change their addresses.

Accugear
(Housings, lights)
724 7th Ave.
New York, NY 10019
(212) 247-7606

Amphibico, Inc.
(Housings, lights)
9563 Cote De Liesse
Dorval, Quebec, Canada H9P 1A3
(514) 636-9910

Aqua Video Underwater Systems, Inc.
(Housings, lights)
450 S.W. 130th Ave. Suite 101
Ft. Lauderdale, FL 33325
(305) 424-2052

Aqua Vision Systems
(Housings, lights)
804 Deslauriers
Montreal, Quebec, Canada H4N 1X1
(514) 336-7051

EWA–Marine
(Flexible housings)
216 Haddon Ave.
Westmont, NJ 08108
(609) 854-2424

Gates Underwater Products
(Housings)
5111 Santa Fe St., Suite H
San Diego, CA 92109
(619) 272-2501

Helix, Ltd.
(Housings, lights)
310 South Racine Ave.
Chicago, IL 60607
(800) 334-3549

Ikelite Underwater Systems
(Housings, lights)
P.O. Box 8810
Indianapolis, IN 46208
(317) 882-0548

Jay–Mar Engineering
(Housings, lights)
1910 Milan Pl.
San Pedro, CA 90732
(310) 833-0577

Leisure Components, Inc.
(Housings)
P.O. Box 13144
Sarasota, FL 34278
(800) 753-6296
(813) 753-6275

Light & Motion
(Housings, lights)
32 Cannery Row
Monterey, CA 93940
(408) 375-1525

Marine Camera Distributors
(Lights)
11717 Sorrento Valley Rd.
San Diego, CA 92121
(619) 481-0604

Quest Marine Video
(Housings)
23382 Madero Rd., #3
Mission Viejo, CA 92691
(714) 498-3170

Sea & Sea
(Lights)
% GMI Photographic Inc.
1776 New Highway
Farmingdale, NY 11735
(516) 752-0066

Sony Consumer Products
(Camcorders, housings, lights)
Video Products Division
Sony 3-6
Park Ridge, NJ 07656
(201) 930-1000

Underwater Kinetics
(Lights)
1020 Linda Vista Dr.
San Marcos, CA 92069
(619) 744-7560

Underwater Research Products
(UR/PRO filters)
P.O. Box 455
Naperville, IL 60566
(708) 961-2622

Underwater Video Vault
(Housings)
20803 No. 19 Stuebner Airline
Springs, TX 77379
(713) 376-2433

··· INDEX ···

A **bold** faced page number denotes a picture caption.